How to ————————
PHOTOGRAPH
PEOPLE ————

Executive Editor: Carl Shipman
Editors: David A. Silverman, Theodore DiSante
Art Director: Don Burton
Book Assembly: George Haigh
Typography: Cindy Coatsworth, Joanne Nociti, Michelle Claridge

Published by H.P. Books, P.O. Box 5367, Tucson, AZ 85703 602/888-2150
ISBN: 0-89586-114-3 Library of Congress Catalog No. 81-82136
©1981 Fisher Publishing, Inc.

How to PHOTOGRAPH PEOPLE

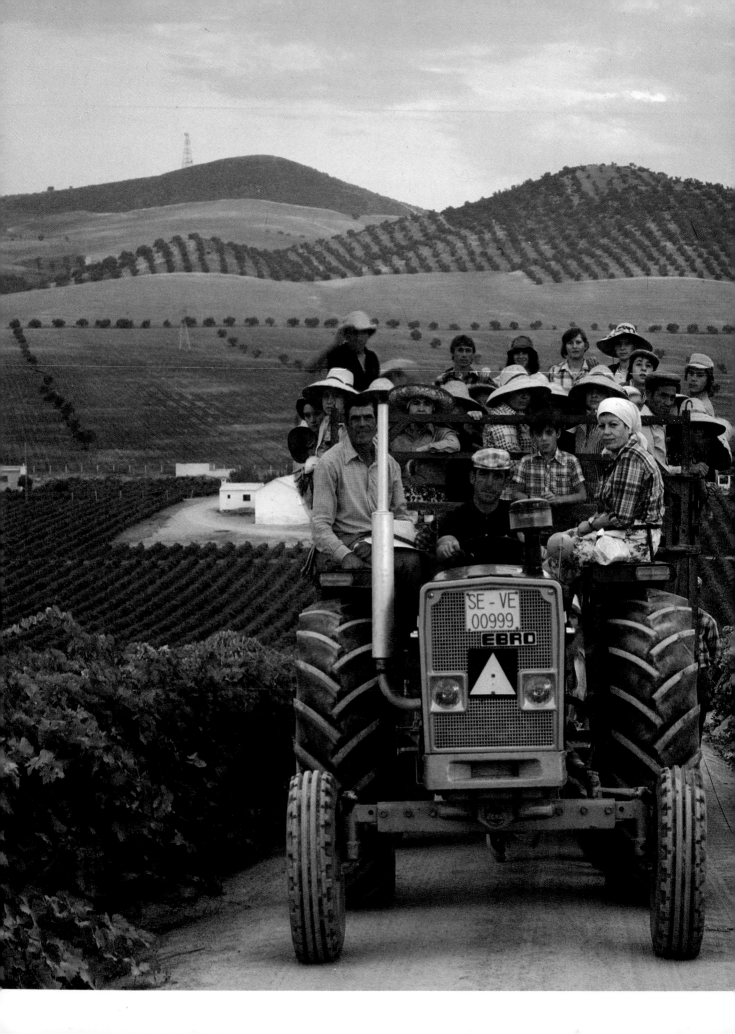

Contents

Choosing an Approach

People can be the most rewarding and the most difficult subjects to photograph. The challenge is not technical, such as which camera to use or what lighting is best. It is making the photograph reveal something *about* the people you are portraying. A *good* photograph tells the viewer more about the subject than just what he looks like. It may show what he does for a living by including the tools of his trade, or it may capture a particular expression that typifies his personality.

Many people feel uncomfortable in front of a camera. They don't realize that the photographer may also feel uneasy. Consider the different ways to approach the subject and decide which one best suits both you and the subject. For example, if both of you are shy, there will be less tension if the subject is not aware that he is being photographed. He will behave naturally and you can then take your time.

There are three basic approaches to photographing people:

Fully-aware: The subject knows he is being photographed and cooperates to achieve a planned result. You are in complete control.

Semi-aware: The subject knows you are present but is absorbed in an activity and is not sure of the precise moment you make the exposure.

Unaware: The subject does not know he is being photographed.

Later sections of this book explore each approach in detail. But first you should familiarize yourself with the general principles of each, and decide which is best for a given situation.

FULLY AWARE

If you choose the direct approach, think of the photo session as a combined effort. Convey this feeling at the start and you encourage the subject to become an active participant instead of a passive and self-conscious model.

Whether you photograph the subject indoors or on location depends on the style of photograph you desire. Decide before you start what you want to show. For example, you could make a head-and-shoulder photograph of John Smith, the man, or include a violin under his arm and have a picture of John Smith, musician.

Eyes are Important—Eyes are the natural focus of attention. The emphasis of a portrait changes when the subject looks straight at the camera rather than away. When photographing a nude, a change in the direction of the model's eyes can turn

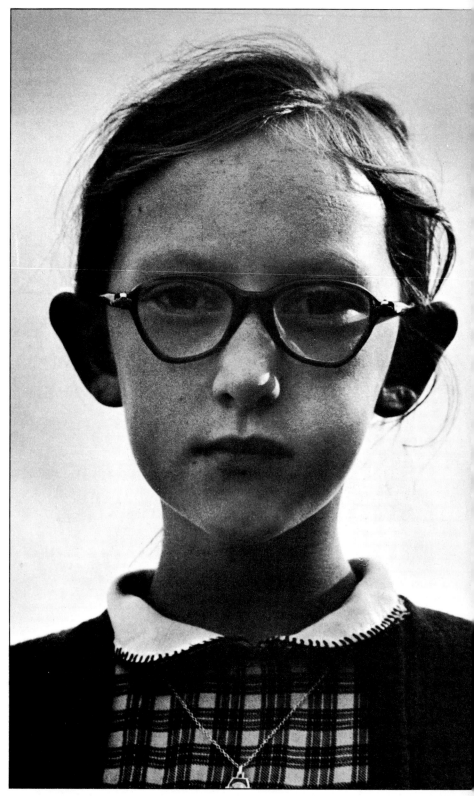

FULLY AWARE
▲ Photographer Dorothy Lange captured the serious look of a child, completely unembarrassed by the camera. A plain background helps focus your attention on her face.

UNAWARE
▶ Skillful use of background helps identify these two ladies as residents of a village in Europe. Frame them with your hands to see how less background would have told less about the subjects. Photo by John Bulmer.

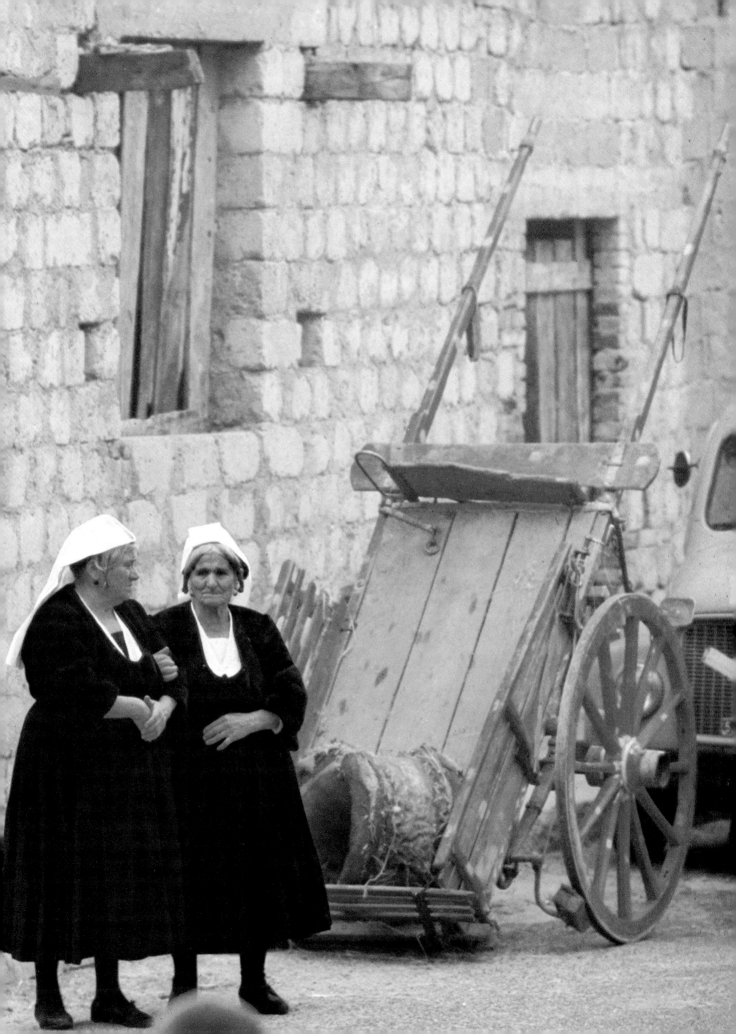

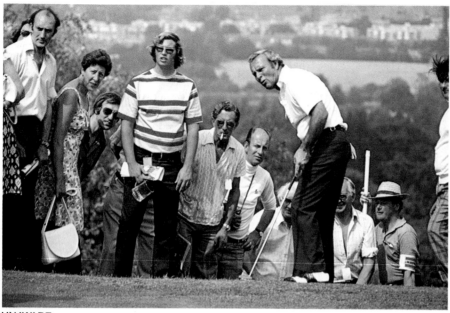

UNAWARE

▲ Because a telephoto lens was used, the golfer and spectators weren't aware of the photographer. The lens compresses perspective, making everyone look closer together. Photo by Robin Laurance.

AWARE

▲ By seating the mother and child, photographer Robin Laurance also gave the father a prop to lean on. This is a relaxed and happy family portrait.

AWARE

▶ Back lighting often gives better results than direct sun. Here the subject laughs at the camera without squinting, and her hair is appealingly lit. Photo by Michael Busselle.

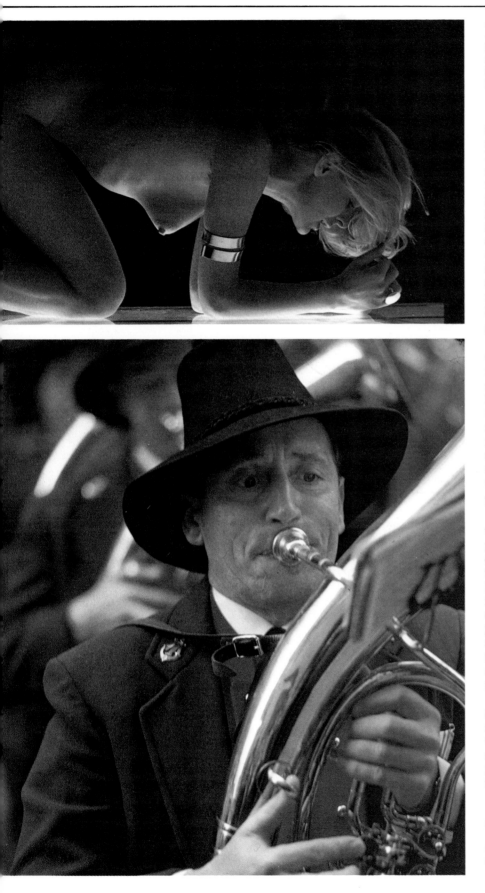

a quiet reflective pose into something more sensual.

Plan Ahead for Groups—Group pictures require the most planning. Good organization leads to confidence on everybody's part. Find alternatives to just lining up the people. Whatever the setup, you must see all the faces clearly. Explore different camera angles. Working from a chair or other elevated position gives you a better angle so you can crowd the group together and still have all the faces showing. If you use a wide-angle lens, its greater depth of field will keep more faces in focus.

SEMI-AWARE

This approach is particularly successful when the subject feels uneasy in front of the camera. If he is doing something—a violinist at a rehearsal, a fisherman mending his nets, a child playing with a toy, an uncle with his stamp collection—he will be more relaxed. And if the subject is occupied, you do not feel rushed to make the exposure. You can produce a more interesting photograph by using "props" from that person's environment.

UNAWARE

When making photographs of a subject who is not aware of your presence, the problem of getting him to look natural does not exist. This is called *candid* photography. With this approach, you are no longer in control of the situation and must recognize the precise moment to make the exposure. Although you lose the control you have in a posed session, you have access to completely natural behavior. A telephoto lens is invaluable because it allows you to keep your distance and retain spontaneity.

Let your photographs tell a story—about a relationship, a human condition or an amusing situation. Don't always feel obliged to show faces. A rear view can sometimes tell the story with added poignancy or wit. The important thing is that your photographs interest the viewer.

SEMI-AWARE

◄ This member of an Austrian brass band knows he is being photographed, but his concentration is focused on reading the music. Photo by Patrick Thurston.

The Semi-Aware Subject

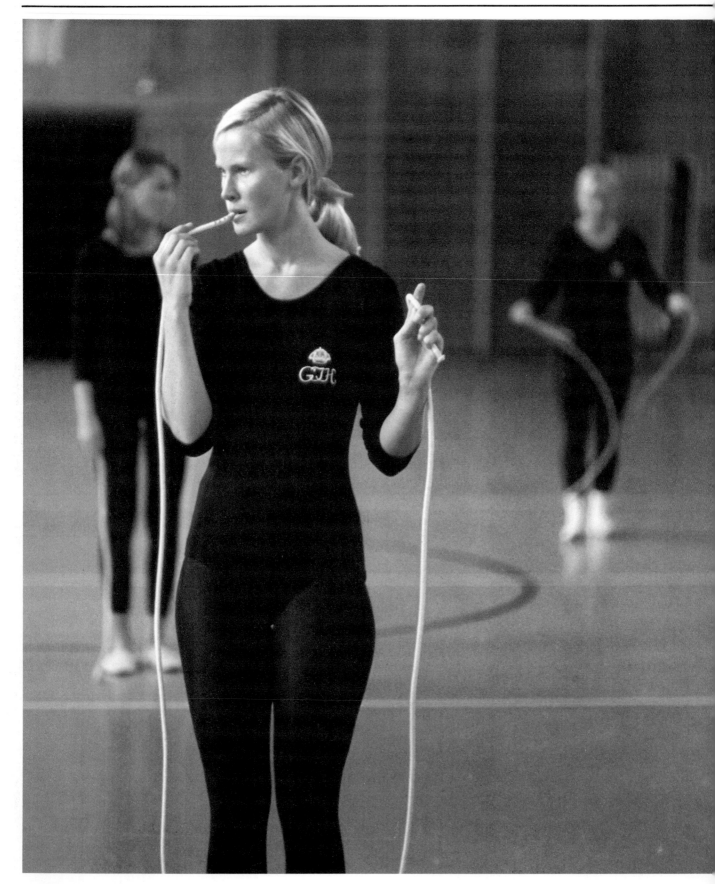

Perhaps the *semi-aware* approach is the easiest to master when photographing people. Here, you photograph a subject who is concentrating on something other than you and the camera. This is the middle ground between the extremes of the formal pose and candid photography. It allows more control than candids, yet retains much of the spontaneity of an unaware subject.

People at work or play are ideal subjects for this type of photograph. A studio and studio lighting are not necessarily required. And, with your subject fully distracted, he is more relaxed. Thus, you have the chance to work out the technical details at your own pace while making a photograph of more than just a face.

PLANNING THE PHOTOGRAPH

It is important to *look first* and *take the picture later.* Identify the most photogenic elements of the subject. Plan the photograph in your mind. Ask yourself what you are trying to show. Is a blacksmith best portrayed by a close-up of his face, or would a horseshoe glowing above the coals add more to the picture? How can you capture the boisterous personality of a street vendor?

Think about how you can tell more about individual members of your family by photographing them while they are involved in activities around the home, such as washing the car, mowing the lawn, gardening, or relaxing with a book. Thinking about photography in this way should give you plenty of ideas for taking pictures of people in everyday activities.

You might also consider staging pictures. Some photographers believe photography should be pure truth and that staging a picture—even an action replay—is wrong. Others believe the final image is important and that any means to that end is justified.

Spontaneous or Planned—There is the satisfaction of capturing the reality of the moment. There is equal satisfaction in planning and constructing the image. It is simply a matter of choice. You will probably use both approaches.

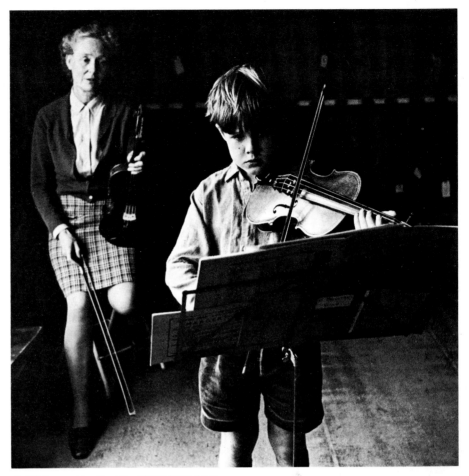

▲ White music sheets reflect light from a window onto this boy's face. Using a wide-angle lens, photographer John Walmsley focused on the student and used an aperture small enough to keep the image of the teacher sharp.

▼ To portray this family in a confined kitchen area, Anthea Sieveking used a high camera position and a wide-angle lens.

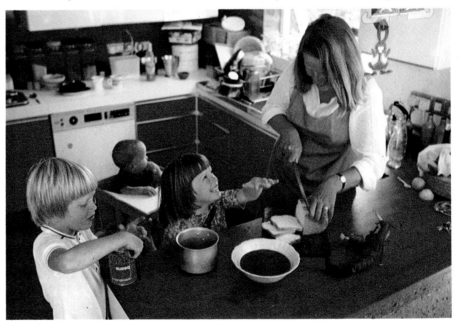

◄ Photographer John Bulmer photographed a gym class using a telephoto lens. He let the women get used to his presence and waited to catch this expression.

If you choose the "purist" approach, think ahead and try to foresee how the situation is going to develop. Be prepared. Find the best camera position and cut the reaction time between what you see and when you press the shutter button.

If you do choose to stage the photograph, the subject will become aware of the camera. Give him time to become absorbed in his activity again before making any exposures.

When you are photographing people who are partly aware of the camera, you will often be working outdoors with natural light. When working inside, be aware of the lighting conditions. For example, the subject's face may be well lit, but not his hands. This is not good if the subject's hands are an important compositional element. Be sure the light is even, and reposition him if necessary.

When working outside, don't be afraid to shoot into the light. When you do, remember to compensate for back lighting by giving more exposure than the meter recommends. This compensation is usually about one extra exposure step, and results in good detail in the subject. Always use a lens hood under such conditions.

Foreground and Background—Foreground and background can be a help or a hindrance. A busy background that has nothing to do with the subject can be distracting if reproduced sharp in the photograph. Move in close and decrease the depth of field—the zone of sharp focus—by using a large lens aperture, such as *f*-2. The larger the aperture, the shallower the depth of field, causing the background to be out of focus.

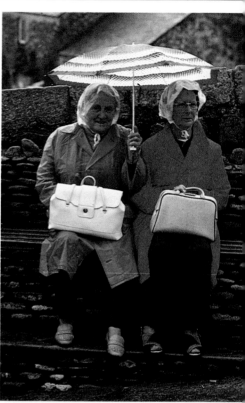

▶ To compensate for the shade of the umbrella, Malcolm Aird opened the aperture 1/2 step more than indicated by the exposure meter.

▼ This photograph has been composed to include foreground and still keep the woman's head as a dominant element. No space is wasted above or at the sides. Photo by Roland and Sabrina Michaud.

Conversely, you may want the foreground or background to be in focus—such as tools or items around the home, office or garden. For a specific *f*-stop, the shorter the lens focal length, the greater the depth of field. If you can't change the lens, select a smaller aperture to increase depth of field. Foregrounds don't have to be absolutely sharp, however. *Suggesting* a row of bottles by having them blurred in front of a machine operator at a bottling plant can be as effective as actually showing them.

Including or excluding foregrounds and backgrounds can also change the emphasis of a picture. Basically, a wide-angle image of a potter with his wheel in the foreground and examples of his work in the background is a picture of a potter. But if you go in close and focus on his face so it fills the frame, you have a portrait of a man who happens to be a potter. Decide what you want to emphasize before you start the portrait session. Or, try it both ways and see which of the two images gives the effect you want.

Consider a Series of Photos—Consider making and displaying a *series* of individual photographs, each one concentrating on a different aspect of the subject. It adds up to a photographic biography, with a few images doing the job of thousands of words.

SHUTTER SPEEDS

As with the choice of lens and aperture, shutter speeds are also important. Of course, the shutter speed depends on your choice of aperture and film speed. But there will be times when you should select shutter speed first and take advantage of its effect. Imagine a harpist's fingers moving across the strings. If the musician's head remains still, you can shoot at a speed as slow as 1/30 or 1/15 second to slightly blur the fingers and hands, accentuating their movement in the image.

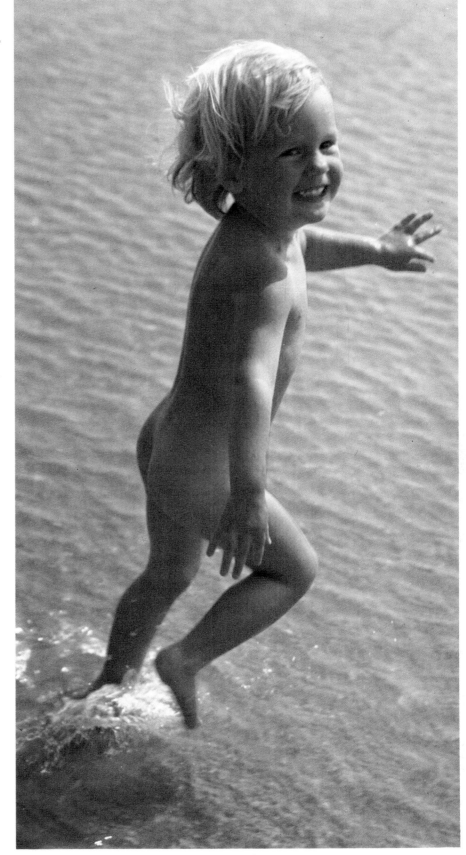

▶ Using a fast shutter speed to freeze movement, Malcolm Aird pointed the camera down to provide a plain background.

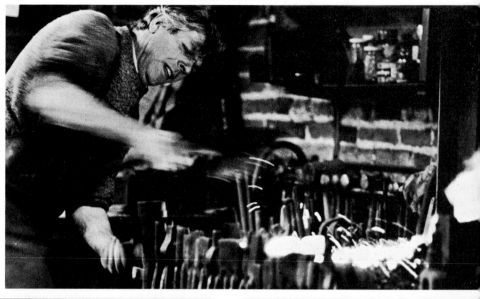
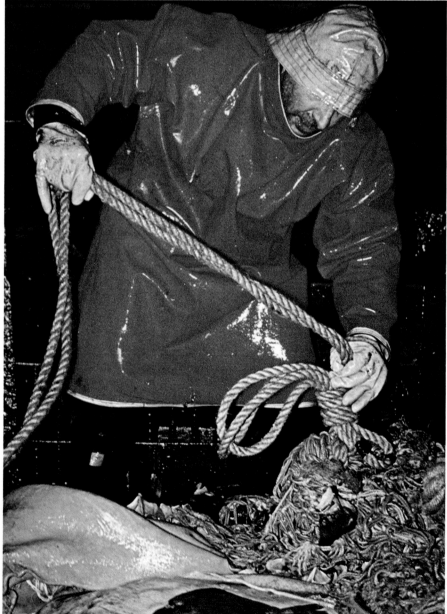

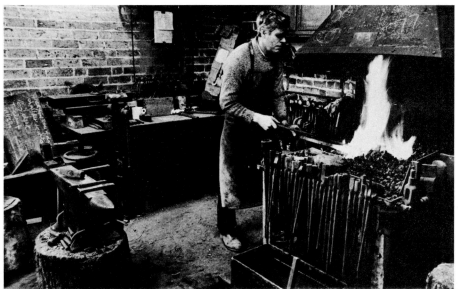

◀ To portray a blacksmith at work, Robin Laurance used three different approaches. At far left, he used a telephoto lens to blur the background and emphasize the face. Center, he chose a slow shutter speed to accentuate arm movement. Then, with a wide-angle lens, he included the man's working environment.

Opposite page, bottom: The photographer waited until the fisherman's hands were far enough apart to fill the picture frame. Photo by Bryn Campbell.

▼ This is a posed "replay." The photographer asked the craftsman to repeat part of the process. Photo by Homer Sykes.

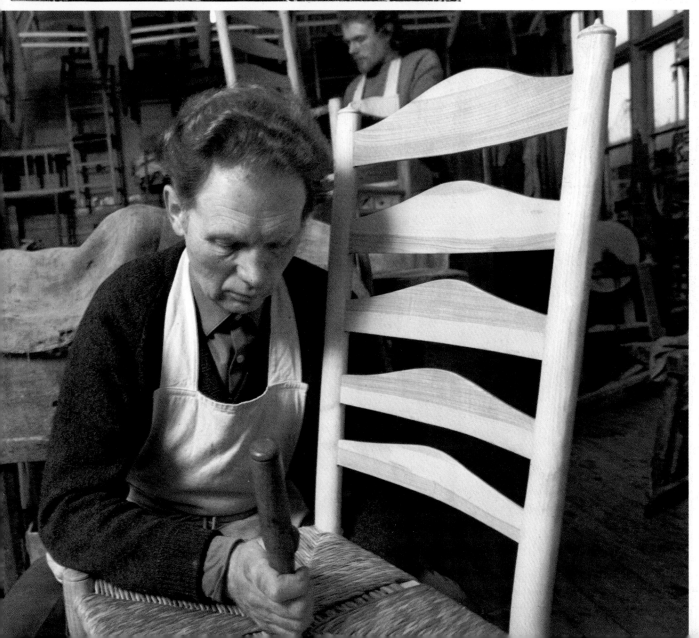

Candid Photography

At no other time is the photographer less in control of his subject than in candid photography. Taking pictures of people who are completely unaware means that you can't arrange lights, backgrounds or the subject's position. Despite these difficulties, however, candid photography is extremely popular because it offers a way of documenting people as they really are, with their emotions and eccentricities unguarded.

THE QUIET APPROACH

The key to candid photography is being able to mingle inconspicuously. A 35mm camera is practical because its small size makes it unobtrusive, it is relatively quiet to operate and it can be loaded with 20-, 24-, 36- or even 72-exposure rolls, enabling you to make a series of exposures quickly without having to change film.

When picture content is most important, use a fast film such as ASA 400. Then you are less hampered by poor lighting or a moving subject.

It helps to keep your distance so the subject doesn't notice you. A telephoto lens, such as a 105mm, 135mm, or a zoom is useful, although it is not essential. In fact, a longer lens can work against you by isolating the subject from his environment. When used from the same distance, a standard 50mm lens on your 35mm SLR covers a larger area to include the subject and more of the surroundings.

Another alternative is to move in really close with a wide-angle lens. This gives the viewer a feeling of being close to the action. One problem with this method is that, as the subject gets closer to the lens, more image distortion occurs.

ASKING PERMISSION

It is not illegal to take pictures of people without asking their permission. You can photograph them in any public place, such as a street or park. This may not prevent you from feeling you are intruding. However, the subject may be less concerned than you imagine, and may even be flattered. Regardless, be polite and considerate; if you are asked not to photograph someone, respect the request. Even though it may be legal to take a picture, there are legal restrictions on what you can do with it. For example, you may not be entitled to sell it.

BE PREPARED

Although luck plays a part in any successful candid photograph, your anticipation is also very important. Getting the image you want requires more than just technical know-how. Be prepared for the moment when the right expression or action appears. Try to foresee how a situation is going to develop and anticipate people's reactions.

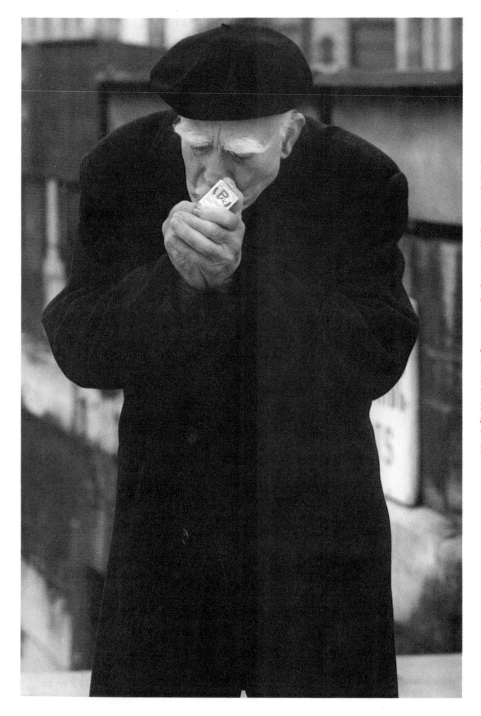

◀ The photographer waited for the right moment to create the feeling of this photo.

▶ A long lens makes it easier to photograph an unguarded moment such as the wistful expression on this lady's face. Photo by John Bulmer.

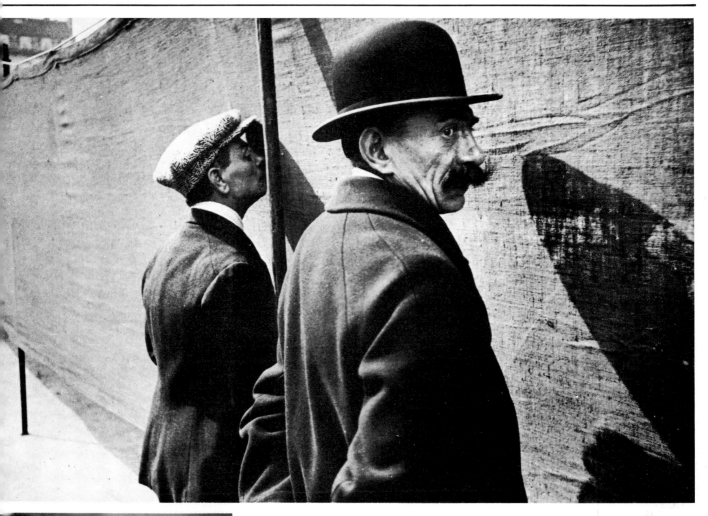

▲ The timeless appeal of candid photography is illustrated in this Henri Cartier-Bresson photograph, made in 1932.

▼ A telephoto lens tends to flatten perspective. Here, John Bulmer gives a sense of depth by including an out-of-focus foreground.

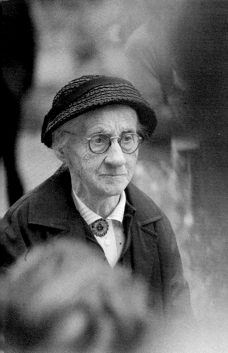

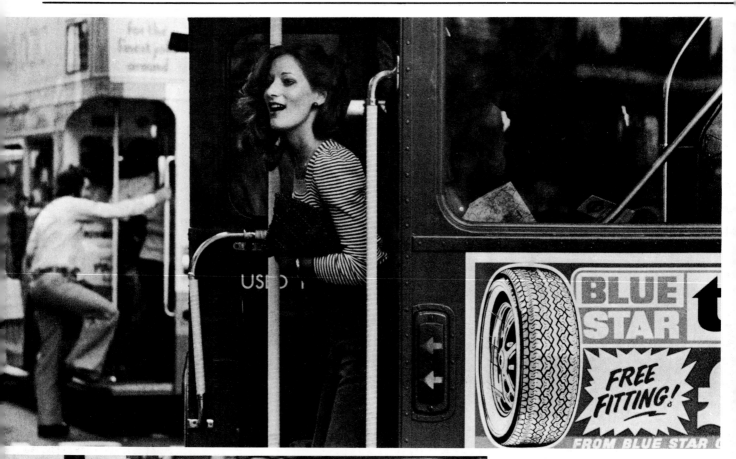

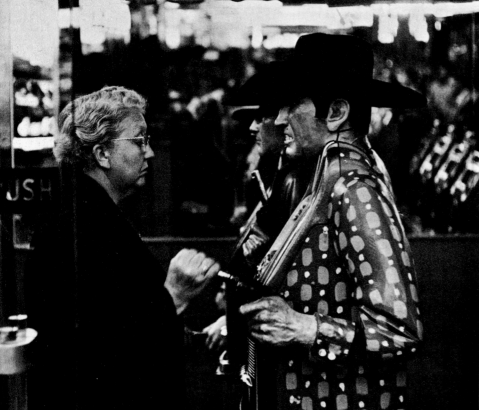

▲ Instant reaction by the photographer caught the vivacity reflected in this woman's face as she stood ready to get off the bus. The doorway provides a natural frame. Photo by Herbie Yoshinori Yamaguchi.

▶ For some photographers, the strength of candids lies in the juxtaposition of elements rather than the glimpse of a private moment in a person's life. Here, Thurston Hopkins recognized the humor of the look-alike chauffeur and poodle.

◀ Gambling Las Vegas-style is parodied in this candid photograph. The mean expression of the one-arm bandit contrasts with the bored look of the woman. Photo by Elliott Erwitt.

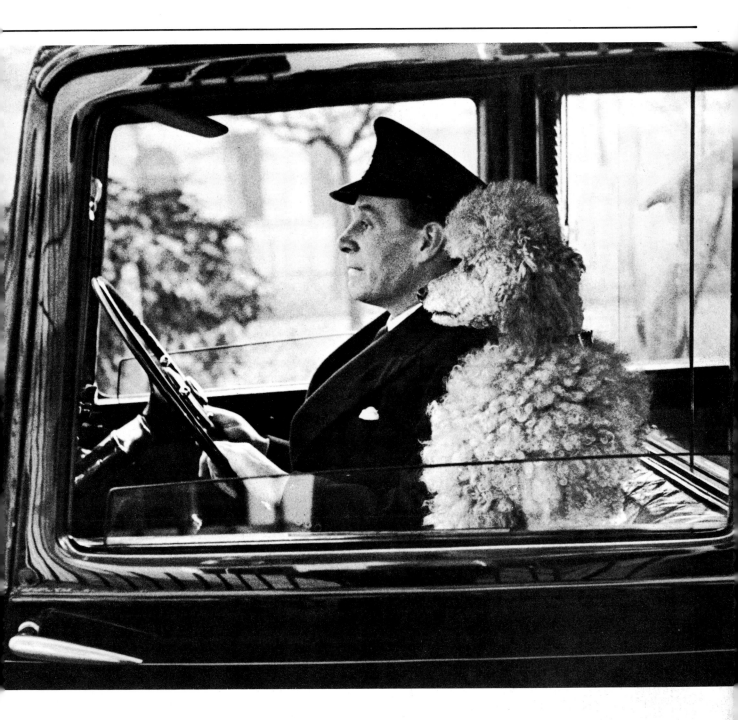

When possible, set shutter speed and aperture before you start looking for shooting opportunities. If necessary, estimate the subject's position at the time you make the exposure, and focus the lens in advance. The estimate should be close enough to require only a slight adjustment when you are ready to make the exposure.

If the scene is bright enough, set the aperture to a high *f*-number. This increases depth of field and provides a margin for slight focus error. Eventually, this will become second nature so you can pay attention to the activity around you instead of to the mechanics of photography.

SELECTING THE BEST VIEWPOINT

Look for opportunities to build a picture around the subject. By choosing your viewpoint carefully, you can create a relationship between the subject and its surroundings for humor, a social statement or simply a pleasing composition. A man sleeping on a bench, for example, contrasts with joggers in a park.

Remember that you are photographing living, thinking, feeling human beings, not inanimate objects. Look for expressions of emotion—love, hate, sorrow, joy. Many of the best photographs show emotion—the love between mother and child or the antagonism between two drivers after a collision are examples.

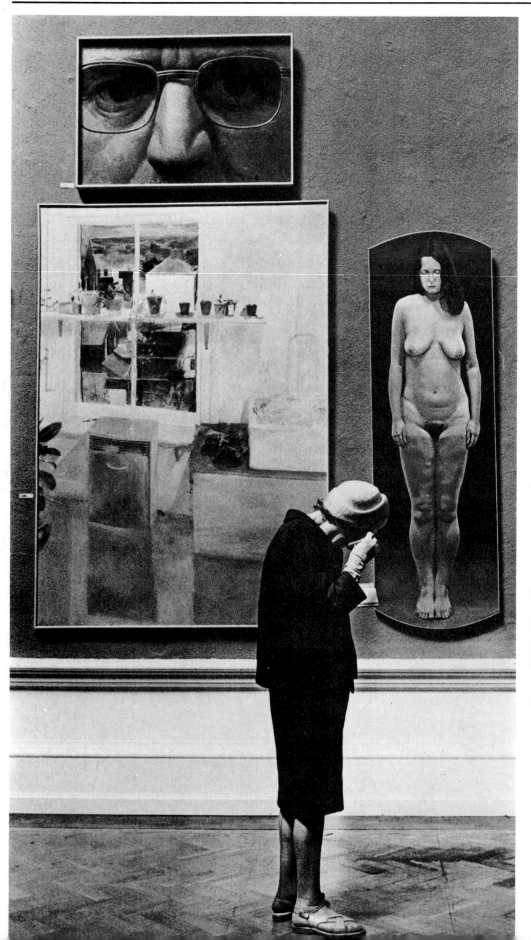

◀ Photographer Robin Laurance found this background and then set his camera for correct exposure. When the woman moved into the scene, he waited for the appropriate moment.

▲ When shooting at slow speeds without a tripod, support the camera any way you can.

▶ These women were so engrossed in the paintings on the wall that photographer Robin Laurance was able to stand right in front of them. He put them in context by using a wide-angle lens.

PLACES TO GO

Finding locations for photographs should present no problems. Some photographers can find photogenic people outside the front door. If you can't, look for more easily defined pictures. At a local museum, look at the people—it doesn't matter what's on display. Concentrate on the visitors and watch how their faces react to the exhibits. You will see quizzical and intense looks, admiration and disinter-est. Find a viewpoint that combines elements and turns a snapshot into a photograph that says something to the viewer.

You can find good subjects at the local park. Joggers, sleepers, bike riders, lovers, dog walkers and people in uniforms provide possibilities. Watch for potential silhouette pictures—lovers against the evening sun, perhaps. Outlines of people should be clearly defined. To do this, meter on the sky.

People and their pets—such as a dog and its owner that really *do* look alike, as shown on page 19, or an old person feeding the ducks—are also fascinating to study and photograph.

As often as you can, look at other photographers' people pictures at exhibitions, in magazines and books. Analyze what makes one photograph better than another. Then use those elements in your own work.

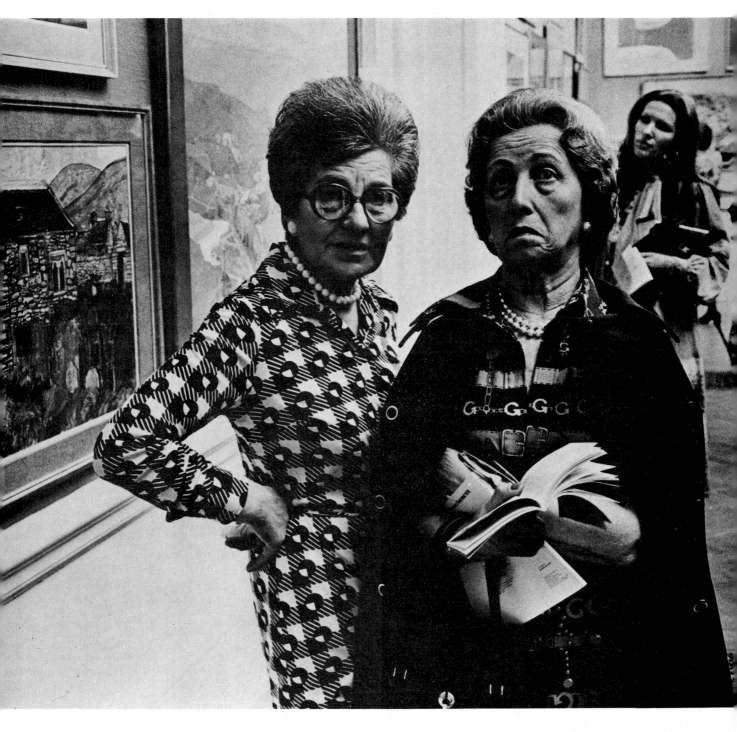

The Planned Portrait

One studio photographer in London never makes more than three negatives during a formal portrait session. He has such complete *control* over his equipment and subjects that three shots are all he needs to get the image he wants.

Control, then, distinguishes making photographs of people who are totally *aware* of the camera from other methods. You can tell your subject where to stand or sit, have him laugh or look thoughtful, choose the position for the best lighting or background. You can manipulate subject, background and equipment for the pre-planned result.

Obviously, lighting is a key part of this control. The next section discusses the use of natural light for photographing people. Later, you'll see effects you can achieve with studio lighting techniques.

RELAXING THE SUBJECT

The most important aspect of portraiture is to catch the character of the person you are photographing—a difficult task unless the subject is relaxed and comfortable. When people are aware of the camera, they often appear to be awkward and self-conscious.

Part of the skill of the portrait photographer is knowing how to relax the subject. Start with a get-acquainted conversation. Discuss things that interest your subject. Express yourself and allow him to do the same. Be sure to explain what you want to do. Ask him about himself and keep him talking until you see he is relaxed.

There are times when a relaxed subject will not give you the image you want. Canadian photographer Yousuf Karsh wanted to capture Winston Churchill's famous pugnacity. When the time came to make the exposure, he found the statesman contentedly puffing a cigar. Determined to get the picture he had planned, Karsh suddenly snatched the cigar away. Churchill was furious, and the photographer got the picture he wanted.

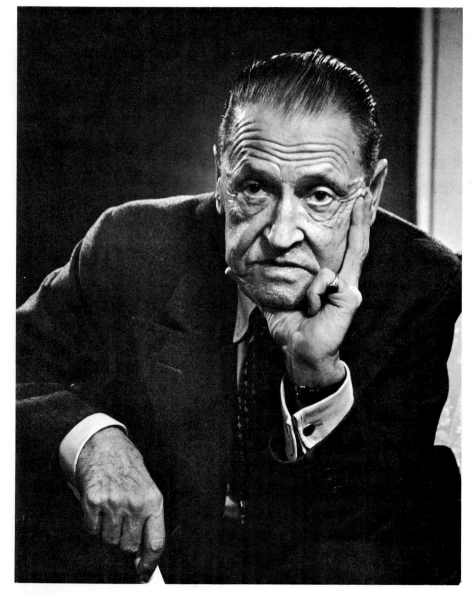

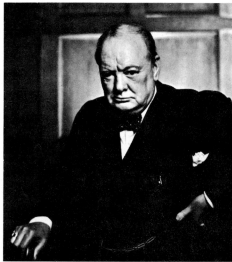

▲ Yousuf Karsh controlled the subject to make this portrait.

◀ By giving author Somerset Maugham something to do with his hands, Karsh relaxed his subject and produced this exceptional portrait. Back lighting appears to bring the subject forward and prevents the shoulders and head from disappearing into the background.

▶ A bank of front lights diffused through tracing paper provided soft mood lighting for this formal studio portrait. The hazy border effect was achieved with a vignetting filter. Photo by Patrick Lichfield.

INFORMAL POSES

You will usually get a more natural-looking photograph if you pose the subject in a comfortable position. An uncomfortable, stiff or unnatural pose often produces a phony-looking portrait. Suggest what the subject should do with his hands. If you don't, you may have a subject who looks and feels awkward.

Don't always have the subject looking into the lens. Tell him to turn away slightly and then have him move his head toward the lens until his head is in a position you like. Or try a profile. This accentuates nose and chin, so it may not be flattering for some people. Make the eyes the point of focus if the subject is facing the camera. Focus on the bridge of the nose if one eye is closer to the camera. Check focus by using depth-of-field preview if your camera has this feature.

Photographing a person in his own environment helps the subject relax and also shows something of his personality. But background detail can be distracting, so many photographers prefer to minimize background emphasis. It is tempting, for example, to turn an outdoor portrait into a landscape. Scenery should form a pleasant backdrop, but not a distracting one. You can lose most of the background by using a larger aperture for less depth of field. For indoor portraits, use a blank wall or cover a patterned wall with a sheet, unless you want the background to imply something about the subject.

A tripod is not always essential. Using a tripod makes the portrait session more formal and means you cannot change camera position quickly. Use one if you can't hold the camera steady for the selected shutter speed. If you want to be able to move away from the camera position for better control, use a tripod to hold the camera, and a cable release to operate the camera shutter from a distance.

▲ This portrait tells a story about the subject. Photo by Tony Evans.

◄ The strength of this photo is its vivid colors and the photographer's technique. A 105mm lens focused at 10 feet (3m) gave very little depth of field. Photo by Spike Powell.

DISTORTION

As you can see in the accompanying illustrations, the results of a portrait session are sometimes disappointing. The image may be distorted because of a technical error, such as using an incorrect lens, or because the subject was not properly posed. The head may have been incorrectly angled, or a barely noticeable skin blemish may become obvious. By altering the angle of view or the pose, you can change the image. Watch for rounded shoulders, stray hair and wrinkles in clothing.

When doing head-and-shoulder portraits, fill the frame with the subject. If you have to enlarge a small portion of the negative to make a print showing head and shoulders only, the quality of the final image will suffer because grain is more apparent. Make the image in the viewfinder as large as possible without causing distortion of features. Look at the viewfinder image very carefully.

▲ A 135mm lens is very good for portraits. It does not distort facial features because you don't have to get close to the subject to fill the frame. Also, the subject does not feel crowded by the camera.

▲ Using a standard 50mm lens close enough to a single face to fill the frame produces some distortion of the nose.

▲ There will be no visible distortion with a 50mm lens at about 7 feet (2m). However, the face does not fill the frame.

▲ If you fill the frame using a wide-angle lens, features may be distorted. You get more distortion as you get closer.

Using Daylight

Many successful portraits are made with daylight only. When outdoors, you and your subject have considerable freedom of movement for natural-looking photographs. When using daylight indoors, the position of the subject is less flexible because you need to keep him close to a window or open door. However, the soft quality of diffused natural light more than compensates for the limitation of subject placement.

USING SUNLIGHT PROPERLY

Even outdoors, proper positioning is important. Because you cannot control the direction of the sun, you must avoid subject positions that will produce unflattering shadows or squinting eyes. If the subject is facing the sun, he will invariably squint. But if he turns so the camera is facing into the sun, lens flare may result. Obviously, a compromise location is best.

The closer you get to the subject, the better. When the sun is high in the sky, the subject will not have to squint, but you must be sure his eyes are not in shadow. Use a lens hood to help prevent lens flare.

Know what kind of light you are dealing with. *Front light* originates at or behind the camera position. *Quarter light* has an angle midway between the lens axis and subject plane, about 45 degrees. A source from one side of the subject results in *cross* or *side lighting. Back light* comes from a source behind the subject. Try not to photograph when the sun is directly overhead. Shoot earlier in the morning or later in the afternoon. For more about lighting and lighting angles, see the companion volume in this series *How to Use Light Creatively.*

REFLECTED LIGHT OUTDOORS

Shaded areas away from strong sunlight are ideal for portraits. Shadows *may* be illuminated by light reflected from surrounding areas, such as green grass, a red blanket or some other strong-colored surface, so you must be careful that the subject is not affected by these colors. Normally there is more reflected light filling in shadow areas than you may think. Meter these areas to be sure you're getting the correct exposure recommendation.

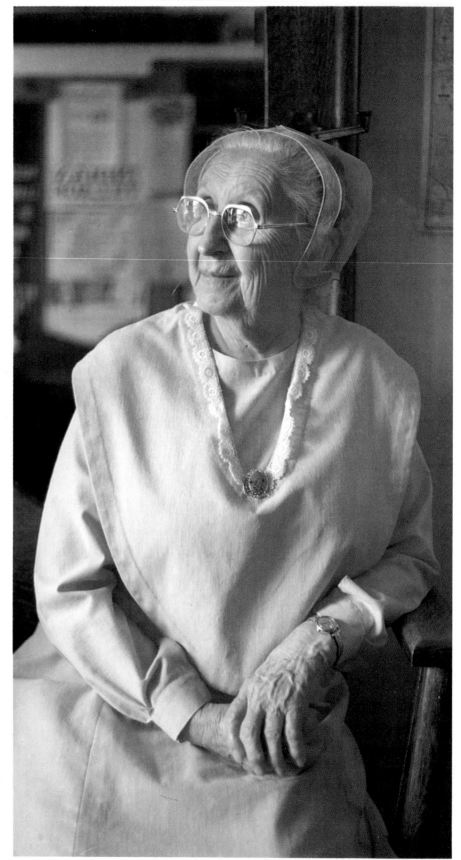

▶ In keeping with Shaker traditions, photographer Chris Schwarz used only natural light for this portrait of a community organizer.

If part of the subject's face is in shade and it is not convenient for him to move, try reflecting light onto the darker side of his face using a piece of white cardboard as a reflector. You may, for example, be shooting indoors with the subject facing away from the window. Prop the reflector on a table or attach it to an improvised stand so it throws light onto the shadow side. Or, ask someone to hold a sheet of newspaper or any convenient light-colored object to reflect some light.

USING SHADOWS

Sometimes shadows can work in your favor by hiding defects such as warts, scars or other skin blemishes. If the subject has obvious blemishes, be sure the lighting angle does not draw attention to them—unless, of course, you want to emphasize them to make a particular point. Remember, a good portrait is not always the most flattering one. Softening the wrinkles on a

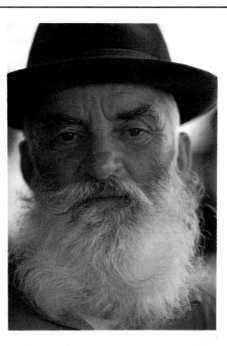

◄ A long lens enabled John Bulmer to get a close-up of this man. Space at the top and sides is not wasted. Natural daylight coming from the side accents the detail of his beard and lined face.

▼ The photographer used a 90mm lens for this close-up of two schoolboys. Light through a schoolroom window illuminated their faces. Photo by John Walmsley.

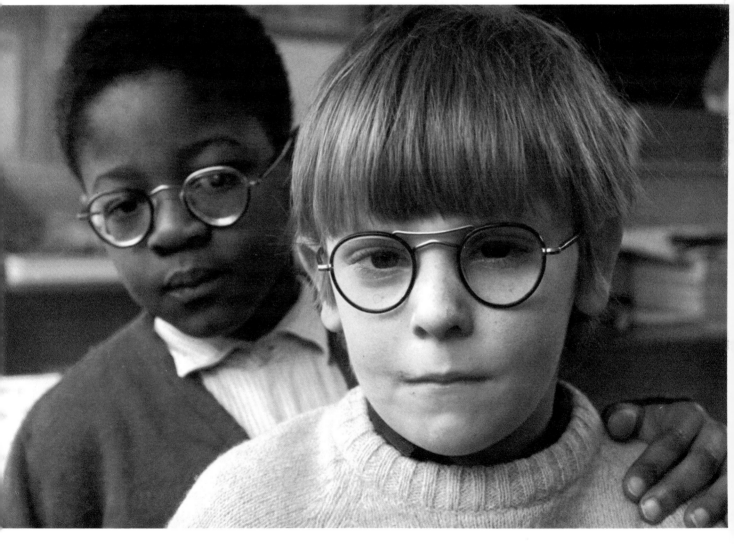

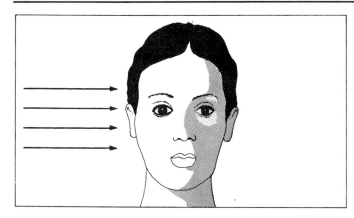

▲ Light from a window at the subject's right causes dark shadows across the left side of her face and neck.

▼ A white reflector held to her left reflects light onto the shadowed side of her face.

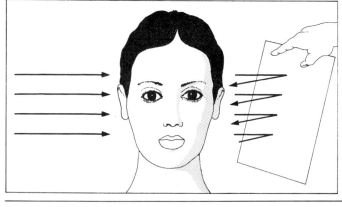

middle-aged woman's face may be flattering to her, but the wrinkles are part of her and tell more about her than smooth skin.

COPING WITH SHADOWS

One problem in portraiture, outdoors or inside, is that shadows can be unflattering.

The best way to understand how shadows are formed is to experiment with them. Have a friend stand in bright sunlight or near a lamp and observe what happens as the person moves relative to the light source. Light strikes the face at different angles. See how light from the side causes a shadow of the nose to fall across the cheek, or light from directly above causes shadows on the eyes or under the chin.

Move the light source closer to the subject to see how distance affects the shadow. You can often deal with such problems by asking the subject to alter the angle of his head or by moving the camera position to get the most flattering results. Or, you can use reflected light to fill in the shadowed area.

Problem—Almost everything is wrong. Shadows have filled in the subject's eyes, emphasized smile lines and obscured parts of her face.
Solution—Move the light to the front and slightly to the side. Use a white reflector on the shadowed side.

Problem—Side light from the left leads to a shadow of the nose across her face and leaves her right side in darkness.
Solution—A white reflector on her right would have reflected light onto the shadowed side of her face.

◄ Far left: The photographer has not filled in shadows.

◄ Left: Using a reflector to fill shadows produced a picture worth framing.

Problem—The hat casts unwanted shadows.
Solution—Remove the hat or use a white reflector to bounce light onto the face.

Problem—The photographer allowed his own shadow to fall across his subject.
Solution—Alter the viewpoint or change subject position.

Problem—Side light from the subject's right results in heavy shadows on her neck.
Solution—Use a white reflector to bounce light under the chin.

A SIMPLE STUDIO

Although a studio with sophisticated lighting equipment may offer the best in controlled photographic conditions, it is not essential for successful portraiture. Even the most modest living room can become an improvised studio. All you need is simple lighting equipment, a plain background and some props.

Natural light coming through a window is often sufficient, particularly if you use fast film. If the light is not bright enough, you can supplement it.

One way of getting extra light indoors is to use flash pointed at the subject or bounced off a light-colored ceiling or wall. Bounce flash gives a more even distribution of light than a flash used on-camera. This is handy if you want to include some of the background. Direct flash focuses attention directly on the subject.

Another approach is to substitute photoflood bulbs for the normal bulbs in your household lamps. As a guide, a 17 foot (5m) square room with light-colored walls and ceiling and one large window may require only one 250W photoflood. These bulbs get very hot, so remove the lampshades if necessary, and compose so the lamps are not in view. When shooting in color, use tungsten-balanced film. Daylight coming in through the window will have a blue cast unless you shoot at night or block the window.

Window curtains create an effective background. Use a less distracting plain sheet if the curtains or background are patterned.

Give the subject a chair. He can sit on it, lean on it or rest a foot. For a formal look, use a well-stuffed armchair or a dining room chair. A kitchen chair gives a more casual appearance.

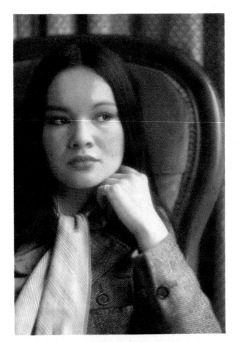

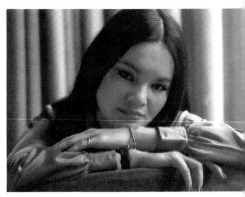

◀ ▲ Because the subject was comfortably seated, she could remain still while the photographer took these photographs using a tripod and slow exposure. He used a diffusion attachment over the lens to soften the image.

▶ To use his living room as a studio, the photographer tied one curtain back and positioned his subject close to the window. He used a white reflector held by an assistant to bounce window light.

▶ Facing page: He used the window curtains as a background. A reflector filled facial shadows without reducing the directional quality of the window light.

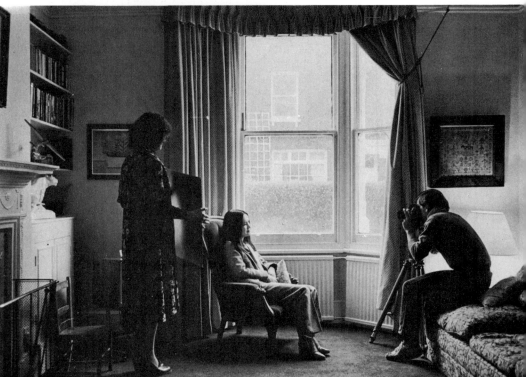

Formal Portraits on Location

As stated earlier, portraiture is not concerned exclusively with physical likeness. You may also want to convey the personality of fellow workers, friends and family—this is more than exact physical detail.

Facial expression tells a lot about a person. Some portraits, usually those made in a studio where the photographer has most control, depend solely on expression for their impact. Here we deal with the other elements of portraiture on location.

CHOOSING A BACKGROUND

To choose a *complementary* background—one that expresses the subject's character—you should know the subject. You may have to do some advance research, or get to know a stranger.

With friends and family—people you already know—a certain background may seem an obvious choice. However, don't neglect research. People often have interests or hobbies that allow you to show them in different surroundings. Photographing people at home or work relaxes them, but is more of a challenge than photographing in a studio.

You should consider *contrasting* as well as complementary backgrounds. A photograph of a mechanic in a workshop may be effective. But if you take him out of the workshop and have him against a plain white background holding a wrench, suddenly every spot of grease, the lines on his face and the wrench gain more emphasis.

Conversely, environment may sometimes make the picture. An old lady against a plain background is just an old lady, but surrounded by family and mementos, she becomes someone very special.

The background, or lack of one, is important in portraiture. It implies something about the subject's character by its color, tone and sharpness, apart from any specific information it may contain.

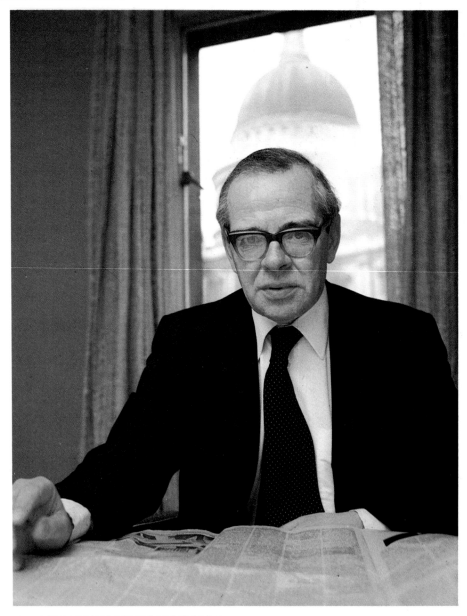

BACKGROUND INFORMATION
In a good portrait, the subject's expression should reveal character. By using a relevant background, you can show more of his way of life.

▲ The dome of St Paul's Cathedral locates Max Fisher, Editor of the *Financial Times*, in the financial heart of London. The newspaper he edits—unmistakable to Englishmen because of the traditional colored paper—is spread out in front of him. Photo by Roger Perry.

◄ The same subject, photographed for a passport picture. Although his expression is similar, the photo tells very little about him.

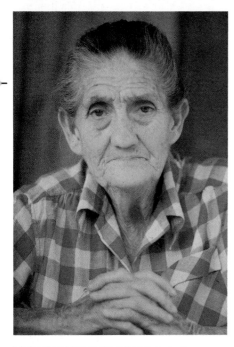

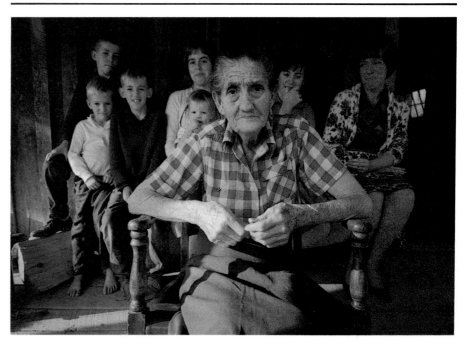

BACKGROUND FOR ATMOSPHERE
Above: John Bulmer photographed this Appalachian woman for an article on poverty. Using an 85mm lens, he concentrated on her dour expression. Right: This view made with a 28mm lens also shows the family. The woman still dominates, but the picture carries a stronger message.

BACKGROUND FOR COMPOSITION
▼ Photographing in low light and with a large lens aperture, Clay Perry used the converging lines of the large room to center attention on the subject. A wide-angle lens exaggerated the size of the shovel and its contents to complete the story.

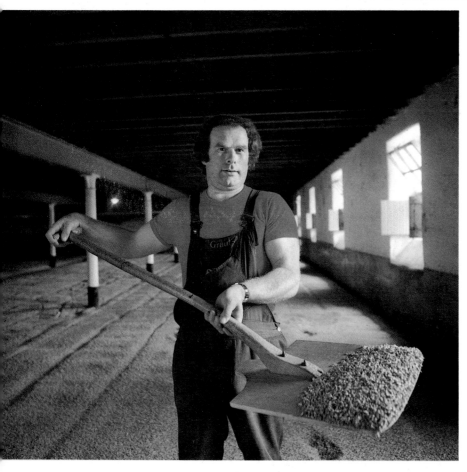

LIGHTING

Location lighting is the portrait photographer's most difficult technical problem. Often, you can't control existing light, but you can modify it with reflectors, diffusing screens and fill lights.

Window light is ideal, although you need a large window to light more than one or two people. As a result, group portraits are normally done outside. The closer the subject is to a window, the greater the contrast between highlight and shadow areas. You can reduce this contrast by filling in the darker side by using a reflector. Or, you can move the subject farther from the window, where contrast is less but the light is weaker.

You can't move available light sources. Move the subject to suit the light. Consider the way a face "changes" as the head turns toward or away from the light. With the light from behind, the hair takes on a halo effect. You can then use a reflector to throw light on the face.

As the head turns toward the light, the cheekbone and tip of the nose are lit, leaving the other side of the face in shadow. As the head turns more, highlight areas increase and shadows diminish until half the face is in shadow and the other half fully illuminated—a dramatic effect in strong light. With three-quarters of the face lit, you have the minimum amount of shadow for a portrait. If the light source illuminates the face completely, it can appear too flat.

POSING THE SUBJECT

Posing people for a portrait is like arranging a still life. The rules of good composition are the same. The image should work as a unit whether you want the subject to look natural or dramatic.

Viewpoint also affects the way the subject appears. A high viewpoint makes the subject look smaller and more vulnerable. A low viewpoint exaggerates the subject's stature.

It is often best to ask the subject to sit or stand in a comfortable position. Then you can compose the portrait by shifting camera position.

EQUIPMENT

A sturdy tripod helps prevent camera shake. And once the composition is set, you don't have to look through the viewfinder again. This means your face is not obscured by the camera, and you have direct contact with the subject as you take the photograph. You may need a cable release for the camera, preferably one long enough to allow you to move around freely.

Almost any kind of camera is suitable for portrait photography. If you intend to concentrate on the face or head and shoulders, the ideal lens on a 35mm SLR should be a short or medium telephoto, about 85mm to 135mm. This lens offers good perspective and lets you locate the camera a comfortable distance away from the subject. The relatively limited depth of field allows you the option of putting a background out of focus.

If you intend to focus on the eyes, and one eye is nearer the camera, focus on the bridge of the nose and stop down the aperture to increase depth of field. Check this by using depth-of-field preview. Eyes attract the viewer's attention in a portrait. If they are out of focus, the portrait will lose much of its impact.

DIRECTING YOUR SUBJECT

Any directions you give during the portrait session must be clear, firm and polite.

You should know the effect you want, so be organized before the subject appears.

Never allow your concern with equipment to interrupt the session. Exposure readings and minor adjustments to lighting or viewpoint will not disturb the subject, but a change of background might. If you spend too much time fiddling with equipment, the subject may become bored or self-conscious, and may lose confidence in your ability. Talk to the subject. It usually inspires confidence if you explain how you want the portrait to look. He will then cooperate more and feel less self-conscious.

For example, if you want him to look to one side, walk to where you want him to look, talking all the time. He will follow you with his eyes. Use a cable release to operate the tripod-mounted camera.

A useful lesson in portrait photography is mentally to put *yourself* in front of the camera. Photographers tend to dislike having their picture taken, and it may help to consider why. Ask yourself, "How would I feel right now if I were the subject?" Modify your procedure accordingly. It is the interaction between subject and photographer that makes the portrait—the camera and film only record it.

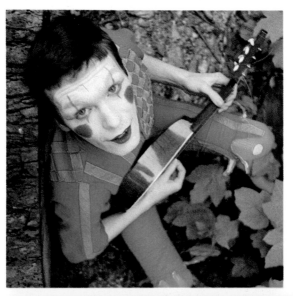

◄ A forest was chosen for the background of these portraits to offset the brightly colored costume and create a magical atmosphere. Laurence Lawry made this photo with a 28mm lens.

▼ Lawry likes to emphasize the foreground in some portraits. Though the subject occupies only a small portion of the picture, he contrasts with the rough texture of the tree trunk and stands out.

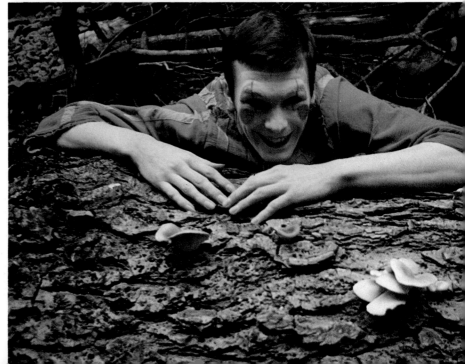

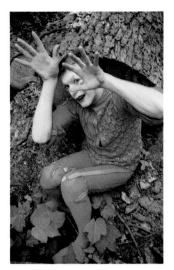

▲ A wide-angle lens can distort the subject's features if used too close. In many of his wide-angle shots, Lawry poses the subject so something other than the face is closest to the camera. In this case, only the hands and arms appear distorted.

► Lawry uses a wide-angle lens so he can remain close to the subject and still get a wide field of view. He can alter background and composition with slight changes in camera angle.

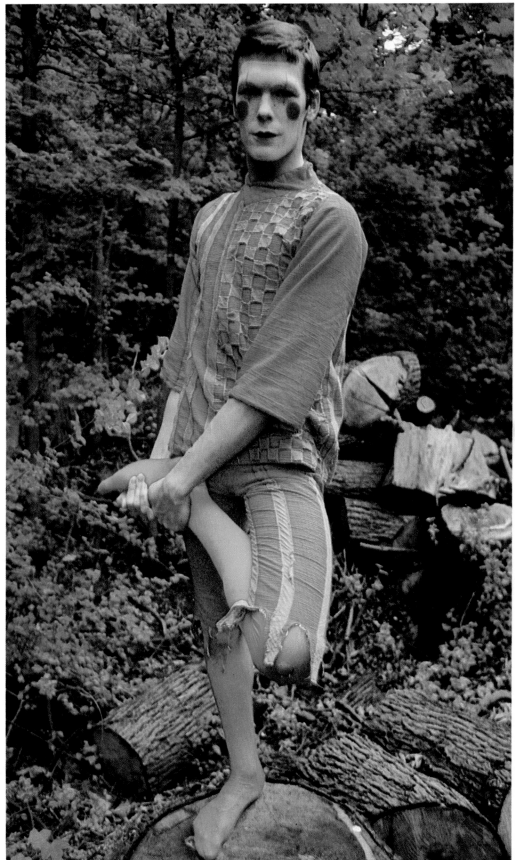

How to Light Formal Portraits

A portrait should be more than a record of someone's appearance. It should reveal some character, too. A person reveals a lot about himself just by the way he dresses and stands. Use these clues to get ideas for portraying your subject on film. On location, you can use the subject's own environment to express this. In the studio, you reveal character with posing and lighting techniques.

ORGANIZING A STUDIO

If you borrow or rent a studio, you also have access to lights and backgrounds. When creating a temporary studio at home, all you need is a plain background, camera and tripod, some lights and a few reflectors. The lighting equipment can be either photofloods or flash. You can make reflectors out of pieces of aluminum foil and white cardboard. If you don't have a plain wall to use as a background, pin a large piece of cloth or background paper to the wall, or use an ironed unpatterned sheet.

It is important to have the studio set up before the sitter arrives. Then you can immediately turn all your attention to him. Nothing bores a subject more than waiting around while you set up your equipment.

Main Light—Always start with a single main, or *key* light. Your choice of a broad, medium or narrow light source will set the mood of the portrait.

▼ Chris Hill took this self-portrait in his new studio. A 24mm lens gives a wide view, making the single roll of background paper seem humorous.

▲▶ Working on location, Clay Perry used a barn as a studio for these portraits of Jeanny Agutter and Alan Badel. He excluded all light other than that coming through the barn door.

Place the main light anywhere on an arc that starts at the camera position and ends slightly behind the subject. The light source should not be lower than the subject's face. Light shining up into a face can look terrible.

Nor should it be at a vertical angle of more than 60°. This results in heavy shadows under the eyes, nose and lips. As the angle between the main light and the camera increases in any direction, highlight areas decrease and shadows take over. This alters both the subject's appearance and the mood of the shot.

The larger and more hard-edged the shadow area, the more dramatic the image. The subject will seem to look more assertive. Large highlights and soft shadows create a gentler, more romantic feeling.

Once you position the main light, decide whether you need more lights or reflectors. You may not need either. One effective lighting setup, called *Rembrandt lighting*, uses one light for specific detail, such as the face, and allows the rest of the subject to fall into shadow.

Fill Light—The simplest way to supplement the main light is to use a reflector to bounce light into the shadow areas. An extra light, preferably a broad source, can do the same thing.

MORE THAN ONE LIGHT

You can use extra lights in many different ways. You may need a broad light source directed into shadow areas if a reflector does not give a strong enough effect. Be careful that the fill light does not cause another shadow—noses with two or more shadows make the subject look rather peculiar. If you find this happening, move the fill light closer to the camera position or bounce it off a reflector to increase its effective size.

You can also use an extra light to create accent highlights. Light directed down on the hair makes the top of the subject's head "shine." Placed behind and slightly below the head, it will create a rim, or halo, effect around the head and shoulders. Be careful that this rim light does not shine into the lens. Keep it far enough away so the subject does not become uncomfortable. Placing a rim light too close may make each hair look like wire and can create too dazzling a halo.

LIGHTING THE BACKGROUND

You can also use extra lights to illuminate the background so the subject does not seem to loom out of deep shadow. To light the whole background area evenly, keep the background light far away and use a broad source.

An unevenly lit background can be used with good effect by positioning the lightest part of the background behind the part of the subject in deepest shadow, or the reverse.

A FOUR-LIGHT SET-UP
Used together, four studio flash units made the portrait on page 39. Only the main light could work by itself.

MAIN LIGHT
This broad light source is at an angle of 45° to the model. The angle caused the dark shadow on one side of her face. This helps emphasize the bone structure.

FILL LIGHT
Bounced from a white reflector, fill light brightens the shadowed side of the model's face.

HAIR LIGHT
Shining down on the model from above, this narrow light source highlights her hair, making it stand out from the background.

BACKGROUND LIGHT
A broad, diffused light source, shining directly onto the background gives the photograph a lighter feel.

▼ MAIN LIGHT ONLY

▼ HAIR LIGHT ONLY

▲ FILL LIGHT ONLY

▲ BACKGROUND LIGHT ONLY

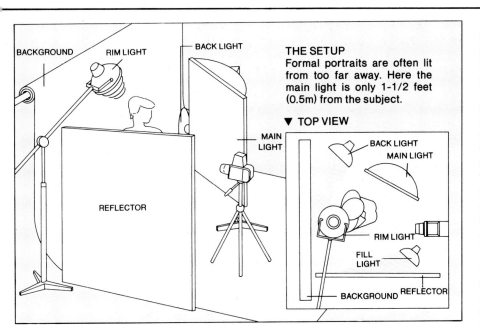

THE SETUP
Formal portraits are often lit from too far away. Here the main light is only 1-1/2 feet (0.5m) from the subject.

▼ TOP VIEW

By combining a key light, background light and rim light, you can give portraits an open, airy feel. To do this, you may have to allow extra space for lights between the background and the subject.

There is no correct number of lights to use for a portrait, but a good rule of thumb is, *the fewer the better.* If you're using more than two lights and a reflector, take another look. Perhaps you can also use the main light to light the background. This is easiest if it is a large source with plenty of spill light that covers a broad enough area to include the subject *and* background.

FLATTERING THE SUBJECT

When you decide how to light a face, remember that everyone has a mixture of attractive and less attractive features. Choose what you want to emphasize and avoid drawing attention to the rest. The simplest way to play down a feature is to pose the subject so that feature does not show.

Shadows emphasize features. Strong side lighting, for example, emphasizes lines and wrinkles that tend to disappear under frontal lighting. Similarly, a strong main light on one side makes the face appear thinner because side shadows emphasize bone structure.

A broad light from the front makes a face seem flatter and rounder. Make baldness less obvious by lowering the camera angle. Minimize double chins by raising the camera.

If the subject has an odd-shaped nose, a profile shot will only draw attention to it. Use a longer lens and broad, front light. Move the camera back and have the subject facing you.

HELP THE SUBJECT RELAX

It is tempting to treat the person in front of you like an inanimate object while you manipulate lighting and camera angles. But the subject is not inanimate, and if you spend too much time on technicalities, he may become tense. Good lighting can bring out character, but if you become too preoccupied with the lighting, the subject will either be a bundle of nerves or so bored that he is no longer worth photographing.

Practice lighting techniques and camera angles on a friend. Observe lighting techniques and their effects on television and in movies, paintings and other photographs. Analyze what you like, and come to the portrait session with ideas and the know-how to put them into practice. Then do it quickly.

▲ FOUR LIGHTS TOGETHER

Portraits of Couples

Photographing two people together is considerably more challenging than taking a picture of just one person. The composition has more elements. Lighting may be more complicated because *both* models must show good expressions before you make the exposure. And, you must establish a relationship between you and more than one person.

If you are shooting a posed portrait, you can control these factors to some extent. For candids, however, you simply have to watch and wait until the elements fall into place.

COMPOSITION

Composition in a posed double portrait provides a happy balance between the two faces. Even with a three-quarter or full-length photograph, the viewer is first attracted to the subjects' faces.

The most common method of composition is to arrange the subjects so their faces are on a diagonal, with one slightly to the left and above, and the other below and to the right. This creates a more attractive shape than positioning the two faces side by side. The balance will still give them equal importance, particularly if they are at the same plane of focus.

Photographs with the two faces side by side can work too, but usually require an additional compositional element, such as hands or arms, to prevent a static arrangement. Some overlap, with one head in front of the other, can create a more interesting design, particularly in a tightly framed photograph.

Composition can show the relationship between the two people in different ways. Make one more dominant simply by having that person's face closer to the camera and therefore larger. Another way to make one face dominate is to have one subject looking straight into the camera while the other is angled to show a three-quarter or even a profile view. Or, the main subject may look into the camera while the other individual looks toward the main subject. This is a technique often used by wedding photographers to emphasize the starring role of the happy bride.

◀ To give the subjects equal emphasis, Clay Perry posed actors Michael York and Simon McCorkindale with their faces on a diagonal line.

▶ The angles of their faces and bodies, and the positions of their hands, arms and shoulders tell a story about these men. Photo by Homer Sykes.

◀ In mother-and-child portraits, you don't want either one dominating the photograph. John Garrett posed this pair to show the mother's protective role without obscuring the baby. Their eyes are on the same level. This emphasizes the difference in the size of their faces, and their reactions to the camera.

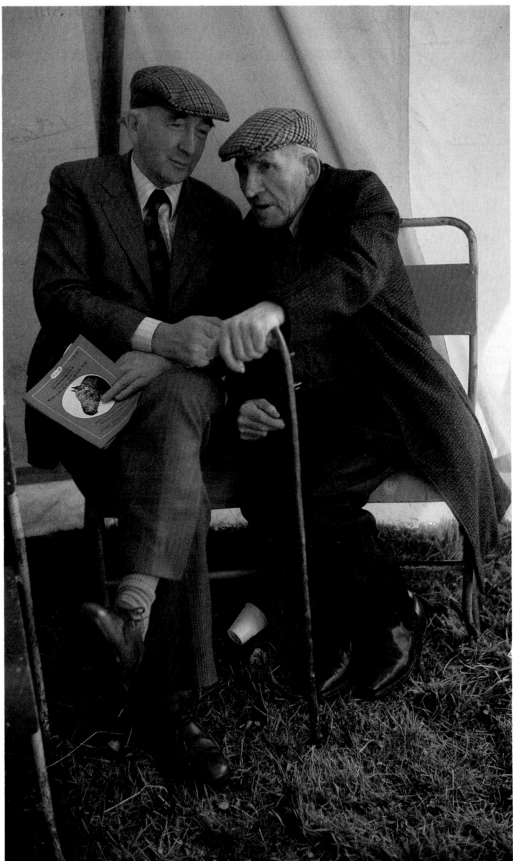

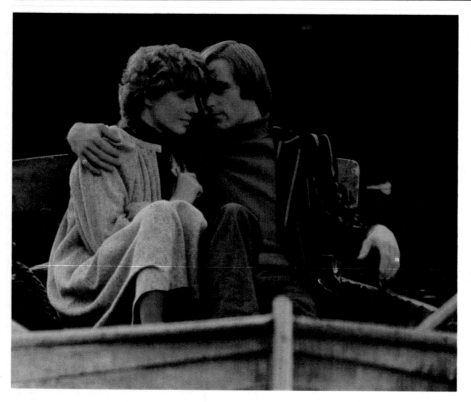

◀ This couple's faces are in soft shadow as a result of backlighting that creates a halo of light around them. This contributes to the mood of the shot and also seems to bring the subjects closer together. Photo by John Garrett.

▼ ▶ Background can tell the viewer a lot about the subjects. Compare the photo on the opposite page with the small section below. Out of context, the people seem separate. You can see their relationship in the complete image. Photo by John Garrett.

IMPLYING RELATIONSHIPS

It's easy to suggest an affectionate and loving relationship when a groom is looking at his bride. This can be enhanced if he places a protective hand on her shoulder or arm. In the photograph, any form of physical contact between two subjects will have a strong influence on the apparent relationship between them. A man and a boy standing together without contact could mean very little, but if the man has his arm around the boy's shoulder, it immediately implies a close bond. The more intimate the gesture, the more intimate the implied relationship.

When directing the subjects this way, it is vital that they feel at ease and can relax in the positions you suggest. Some people are naturally outgoing and demonstrative, but many are shy and don't show a lot of physical affection, especially in front of a camera. Nothing looks worse than a photograph in which the subjects appear to be self-conscious. When you direct the subjects, keep in mind how they behave together naturally. Don't attempt to impose anything on them.

The background can influence the apparent relationship of a couple. A plain background says nothing at all about the people, but a domestic scene in the background implies a family relationship. A soft-focus woodland scene adds considerably to the mood of a portrait of two young lovers.

LIGHTING

Lighting two faces is more difficult than for a single subject. The mood created by lighting can accentuate or detract from the implied relationship of the couple.

The effect of directional light on a face changes with the smallest shift in angle. When lighting two faces, you must compromise somewhat to ensure a pleasing effect on both, particularly when the positions of the two heads are quite different.

The best lighting setup provides even or soft light rather than extremely contrasty or directional light. It also allows the subjects enough freedom to move their heads and change positions without requiring constant adjustment of the light. A single broad, diffused source with a fill-in reflector, and perhaps a little back lighting, will be more satisfactory than a complex setup with several lamps.

The light from a north-facing window is ideal for indoor portraits. Direct sunlight outdoors is best avoided in favor of open shade.

The mood created by the lighting affects the feeling of the picture and the relationship of the couple. It would be inappropriate to use somber, low-key lighting for a portrait of a mother and baby, but it might be ideal for a more formal portrait of two businessmen.

EXPRESSIONS

Another problem with double portraits is capturing two good, characteristic expressions at once. There is no easy solution. Because there is twice as much chance of a photograph being spoiled by one of the subjects frowning, blinking or looking away, you need considerable patience. You'll probably find that you need to make more exposures for a double portrait than for a single. This is the best policy because it is more difficult to watch two faces than one.

Rapport is even more important here than with a single portrait. Mount the camera on a tripod so you can move around. You'll get better results if you can communicate with and watch your subjects without looking through the viewfinder.

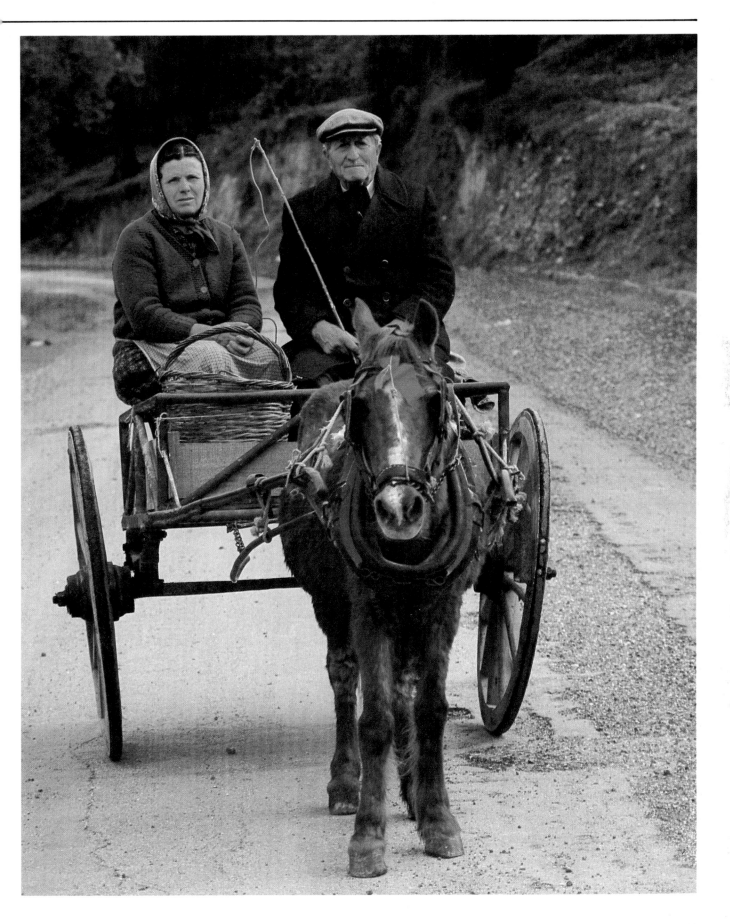

The Planned Group Portrait

For many photographers, the invitation to a social event such as a wedding, bar mitzvah, christening or even a family outing, may be accompanied by a request to bring your camera.

The advantage of photographing people who are fully aware of the camera is that you can expect their cooperation—but you can't always depend on it. With planned groups, self-consciousness is your chief enemy. By the time you have the group you want, you may find that those cheerful faces have turned to stone and the results are unlike the friendly gathering you set out to portray.

The successful group photograph shows every member at his best, yet forms a pleasing arrangement when viewed as a whole. Your biggest problem will be remembering to work on composition while dealing tactfully with the individual personalities.

Plan as much as possible in advance. If the subject is a sports team, for example, think about the color scheme beforehand, and decide what background to use. Or, if the group includes children and adults, decide how to deal with their varying heights.

Planning can save time and tempers. If you can arrange the group quickly, boredom and restlessness won't become a factor. When the session begins, establish your authority right away. Persuade the subjects to think about what you are trying to do. Identify everybody by name, and call them by name when giving directions. Make these directions clear and to the point. If you are indecisive, you will lose their attention.

LIGHTING

For groups, the ideal lighting is bright and even. Before you start shooting, be sure the faces are evenly illuminated. In direct sunlight, you may find the shadow of one member of a group falling across the person next to him. And someone

▲ This Edwardian family was posed against a painted backdrop. Alternating white and black areas are balanced and the babies' legs are arranged to lead the eye toward the center.

▼ You have little control over the situation at a formal wedding. When possible, keep bright colors toward the center and look for details to break a monotonous lineup. Photo by Howell Conant.

almost always squints. The light must be bright so you can shoot with a small lens aperture to maintain a large depth of field and good definition throughout the picture.

ARRANGING THE GROUP

How do you arrange a group in anything but straight lines? Let's consider a group of three. Turn the two people on the outside slightly toward the center, and you already have an improvement on a straight-line composition.

Decide beforehand what the subjects should do with their hands. Make this one of your first instructions. This will not only improve the final image, but will also help the group to relax. People who are self-conscious in front of a camera find this to be one of the most agonizing problems.

If you are moving in close, such as shooting from the waist up, it is best to keep the group uniform, with arms folded or hands clasped in front as a framing device for the bottom of the photograph. If you have more space, try varying the positions more. Have one person with arms

◄ The three bright heads against a dark background form a central pattern here. The white furniture helps contain the group. Photo by Richard Greenhill.

▼ Planned groups need not be formal. The three faces on the right and the leaning figures on the left are carefully composed, yet everyone seems relaxed. Photo by Clay Perry.

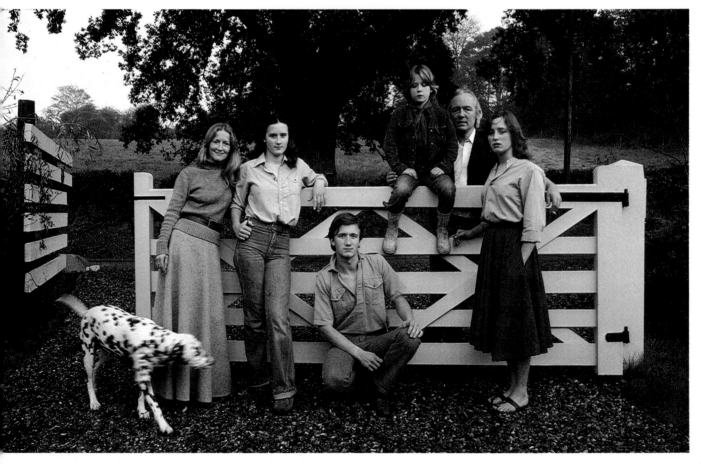

▲ This line-up is unavoidable because these children are standing on a wall. However, lively colors emphasize their mood. Photo by Richard Greenhill.

folded and one with his hands in his pockets or behind his back.

PROPS AND LOCATION

You can tell the viewer a great deal about a group of people by adding props or choosing an appropriate location. You could photograph a group of mailmen holding some letters, or members of the local fishing club near a boat, holding poles and nets.

Vary the direction the subjects look. Make one exposure with them all looking at the camera. Experiment with having them look just above the camera, and to either side. Don't always insist on a smile. Smiles can look forced and unnatural in the wrong situation.

Composing the photograph is easier if you use a prop to organize the group. For example, when working with three people, you can set an armchair at an angle of about 45° to the camera. Ask one individual to stand behind it, the second to sit in it and the third to sit on the arm of the

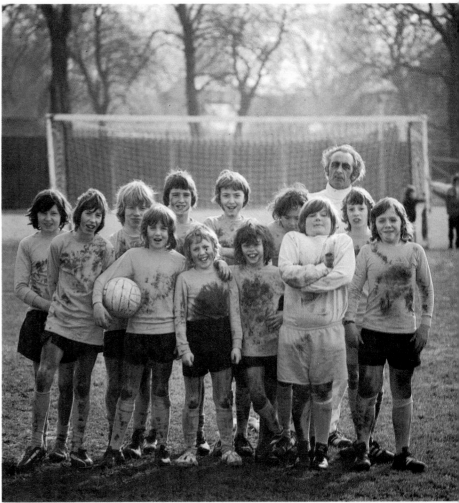

▶ Back lighting makes this group stand out from its surroundings.

46

chair. They should turn their heads toward the camera, but the angles of their bodies give the group cohesion.

The same principles apply when you add two or three more to the group. You may need two chairs or a sofa. Outdoors you can use a bench, a fallen tree trunk or a stairway. Vary the heights of their heads and have those near the outside of the group turn slightly toward the center. To add informality to the picture, have some individuals look toward the group while others look in the direction of the camera. If there are children in the group, have them hold a book or toy on their knees. This keeps them occupied between exposures and adds to the relaxed atmosphere.

◀ Back lighting and low front lighting contribute to a "menacing" mood in this photograph. Photo by Gered Mankowitz.

▼ What begins as a candid photograph may be improved if the subjects become aware of the camera and cooperate. You don't always have to ask them to pose. Shift your position to get the best viewpoint. Photo by John Bulmer.

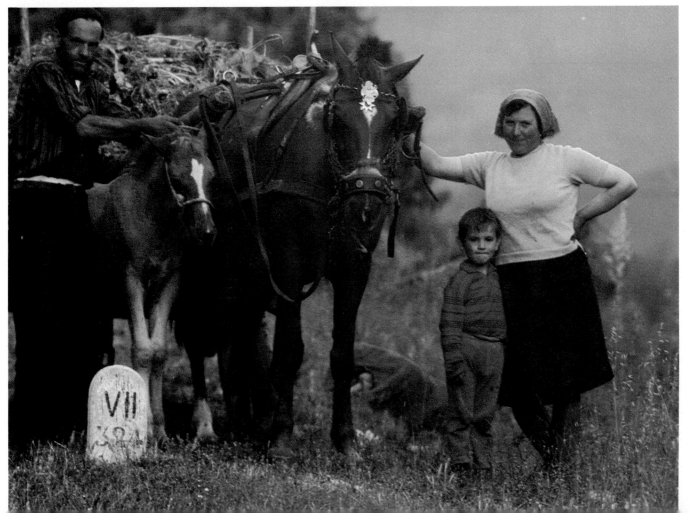

LENS AND VIEWPOINT

With a wide-angle lens, you can give a feeling of depth to group photographs. This appears to bring some group members closer to the camera than others. By focusing on the person in the middle and using a small aperture, you will have everyone in focus. This can be a particularly effective way of underlining the group's hierarchy—a chairman with his board of directors; an airline captain and his crew; the school principal with his staff.

As a general rule, the larger the group, the more formal your approach should be. Three guests chatting at a wedding party suggests an informal grouping. The line-up of bride, groom, bridesmaids and both families needs more organization—partly to give the group cohesion and partly so you can include everyone without sacrificing detail.

With larger groups, you may wish to make the photograph from an elevated position. This gives a clearer picture of everyone without spreading out the group too much. A wide-angle lens helps here too, but be careful that the distortion resulting from tilting the camera down does not become too obvious, especially toward the sides. Have everyone turn inward toward a point about halfway between you and the front of the group. If you are shooting in color and some of the subjects are wearing clothes much brighter than the rest, keep them toward the center of the group.

USING A TRIPOD

Be sure every face is clearly visible in the viewfinder and that feet aren't cut off. Also, there should be no distracting elements in the background. These are too easily forgotten amid other problems of group photography.

It is often an advantage to operate a tripod-mounted camera with a cable release. You are then free to watch the expression of each member of the group. And by moving away from the camera position, you ease some of the tension invariably created by your hovering behind the camera.

It would be the result of good luck rather than good judgement if your first exposure catches exactly the right expression on every face. If ever there is a case for using a lot of film, group photography is it. Everyone is a little stiff at first and, after a while, enthusiasm wanes and the subjects may get bored. You are likely to get the best shot in the middle of the session.

▶ A low viewpoint combined with the distortion of a 24mm lens gave Patrick Thurston an unusual photograph of some members of the Vienna Boy's Choir.

▼ Planning a group photo is one thing; getting cooperation is another. Henri Cartier-Bresson didn't help the photographer at left by stealing the ladies' attention while he made this photo.

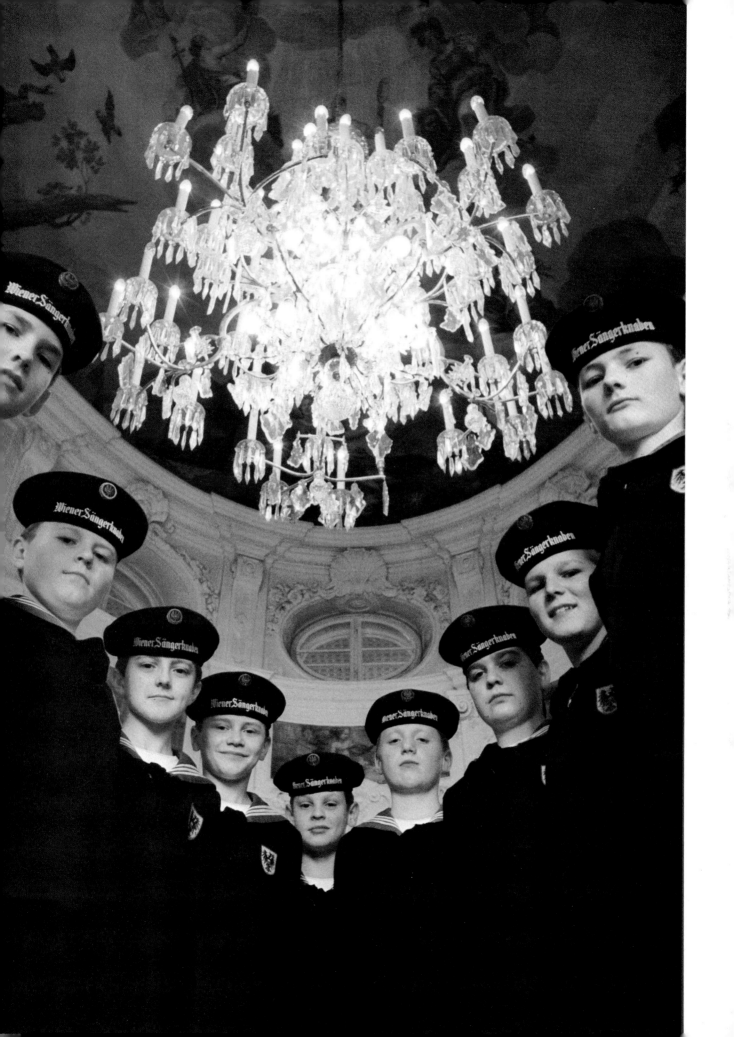

Candid Groups

The vital elements of candid group photography are *watching*, *waiting* and *seizing the moment*. When unaware of the camera, the subjects are caught up in their own activities. It is up to you to find the best way to capture the moment on film. Concentrate on the overall composition of the photograph rather than one or two details.

For example, the famous photographer, Henri Cartier-Bresson goes to extraordinary lengths to compose his candid photographs, sometimes looking at the scene upside down! Photography, he once said, is the simultaneous recognition—in a fraction of a second—of the significance of an event and the precise organization of forms that brings the event to life.

The detail of individual expressions or movements sometimes distracts him from the overall composition, so he places a reversing prism on his Leica while watching the form of the photograph take shape. You can recognize that "precise organization of forms" any way you look at it.

COMPOSING A PHOTOGRAPH

Good composition, vital to all photography, is a principle easily forgotten when taking candid pictures of people—especially candids of groups. With planned groups, you have time to look critically at what's going on. *Candid* group photography requires simultaneous recognition even more than the general photography mentioned by Cartier-Bresson.

Cartier-Bresson did not learn his skills overnight. Every photographer needs training. You can start by looking at other

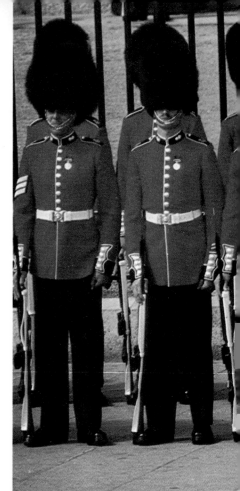

▼ The arrangement of this group occurred naturally. It was up to the photographer to see the shapes, select the right viewpoint and the correct moment to make the exposure. Here, Cartier-Bresson included the boat to balance the composition.

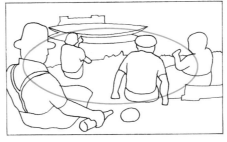

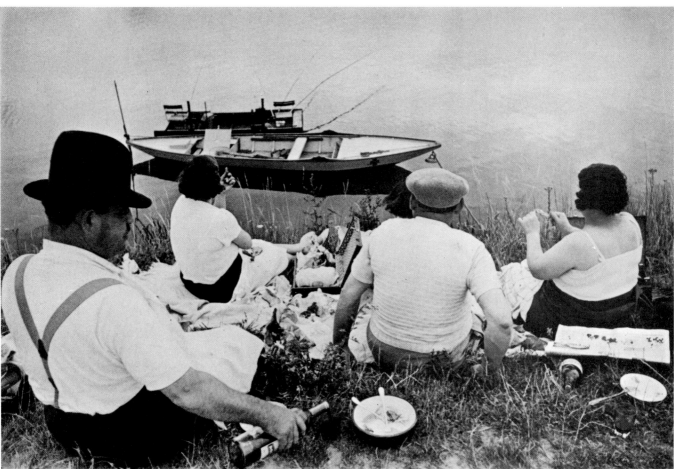

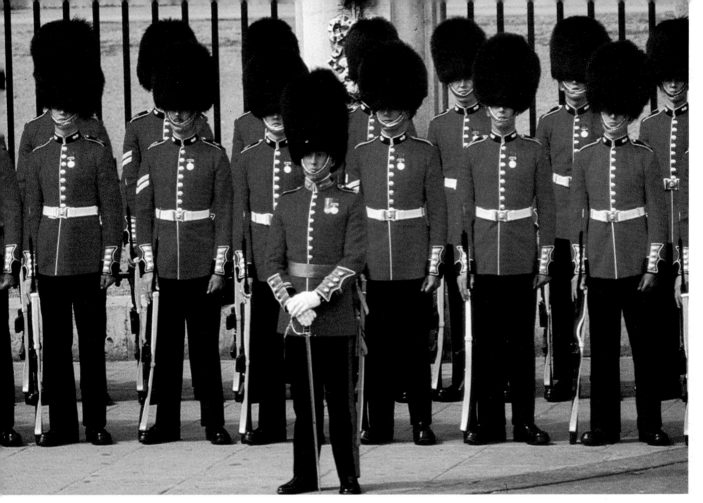

The candid photographer may find patterns organized for him.

▲ Even though composed of verticals, the strong feature of this photograph is the horizontal band of red, barely broken by a lone, off-center figure. Homer Sykes used an 80-200mm zoom.

▶ Viewpoint alters shape. This column of Yemeni boy soldiers has a strong V-shape, made obvious by the uniform waistbands. They were viewed off-center and from a slightly elevated position. John Bulmer used a 180mm lens.

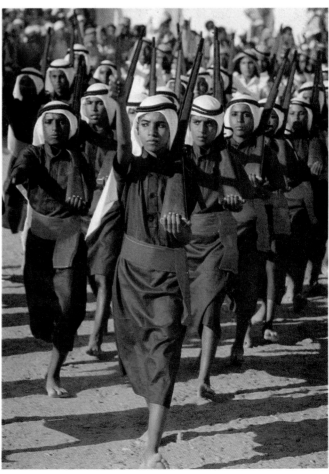

photographers' work and at paintings. When you think the photographer or artist has created a good overall image, analyze converging lines, repeated shapes and juxtaposition of elements to see what makes the composition strong.

One of the first things you will notice is the way a composition changes radically as you raise or lower the angle of view. By placing the camera above eye level, you see people at the back of the group better, and have a greater scope for composition. A low angle can be useful to emphasize people in the foreground.

THE BEST ANGLE

If individuals in the group have some clear relationship to one another, find the angle that demonstrates it best. Think ahead so you are ready for that precise moment when a certain situation or interaction gives the scene added interest. Also watch for unexpected humor, such as a bikini-clad woman talking to a group of nuns, or a bald-headed man in a crowd of long-haired youngsters.

EQUIPMENT

Using a telephoto lens emphasizes crowding by seemingly compressing the

▼ John Bulmer photographed this moment of intense concentration from within the group. A 24mm lens exaggerates the diagonals converging on the chess board.

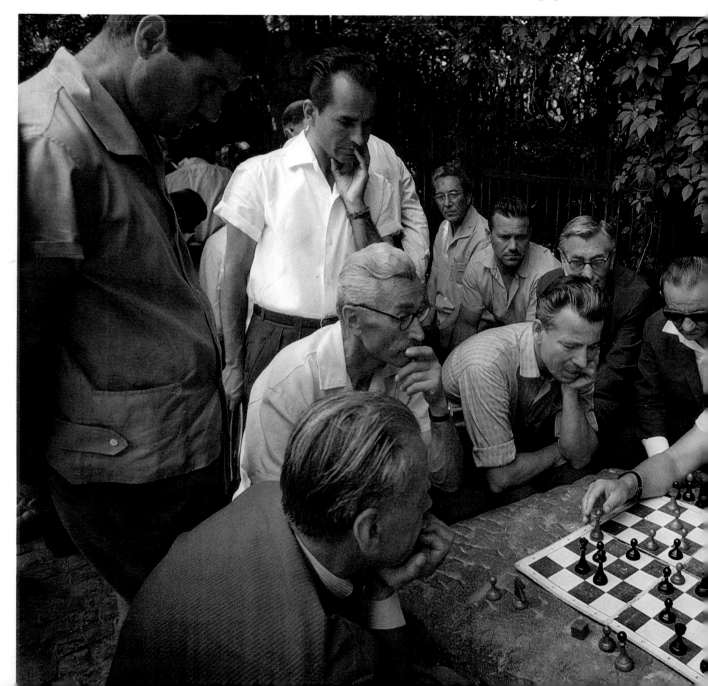

▶ Only with a combination of luck, patience and a well-trained eye can you hope to capture bizarre compositions like Martin Parr's photo of this divided congregation. He gives the two groups equal prominence, breaking a basic rule of composition.

Below right: A horizontal format gives the vertical spears more emphasis, drawing attention to the height of these Masai warriors. The patches of bright color help separate the group from its surroundings. Photo by Peter Carmichael.

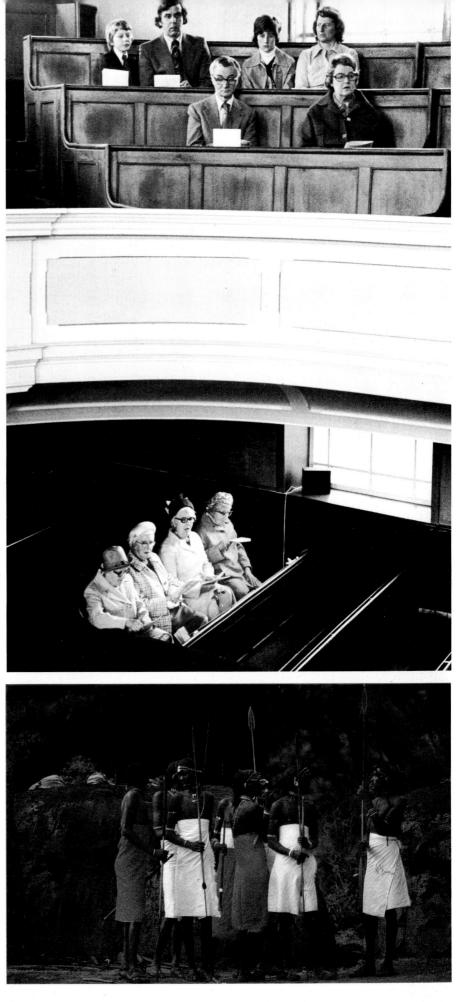

distance between foreground and background. For example, commuters at a bus stop or demonstrators on the march look closer together than they really are. Or, with a wide-angle lens, you can give the viewer the feeling of being right there in the middle of the crowd.

With smaller groups, be selective about the people you include in the image. Choose the viewpoint and lens to exclude people who don't contribute to the photo. For example, if there are three people talking, with another person slightly separated from the group, it will be up to you to decide whether to photograph three friends or three friends and an outsider.

Remember that the "perfect" grouping, once missed, seldom repeats itself. This is another reason for advance preparation. Load your camera with film that is fast enough for the lighting conditions. Check

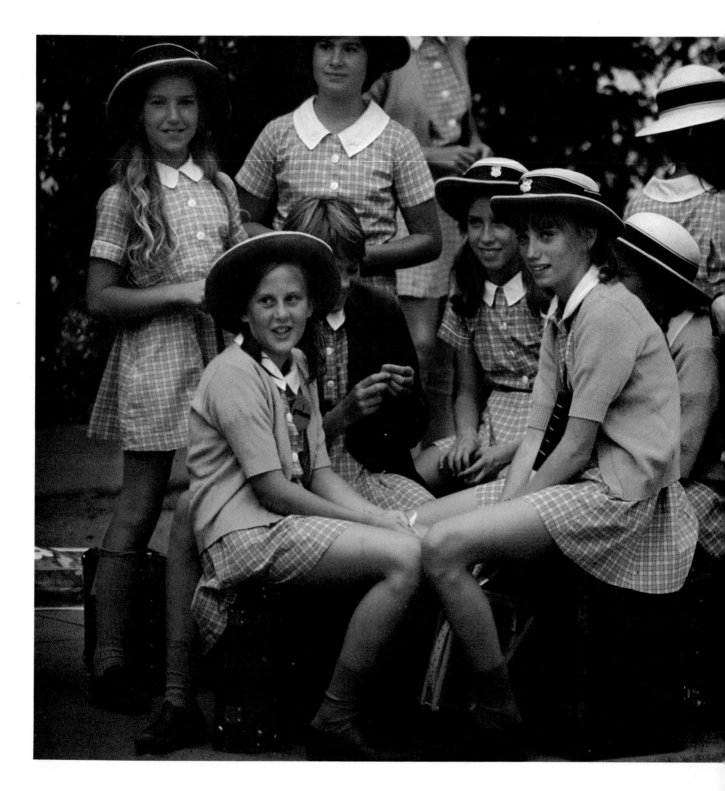

the light and make meter readings before you start shooting. You will have to concentrate on what is in the viewfinder, so set shutter speed and aperture before shooting. Wind the film after each exposure so you are ready for the next.

Be bold. There is no law against taking photographs of people in public places wherever you find them. Some may object and you should respect their wishes. But in most cases, either the subjects will not be aware of your presence or they will be flat-

tered by your interest. More often than not, they will start posing for you. This can spoil the spontaneity of the situation, so try to make a few exposures before you are noticed.

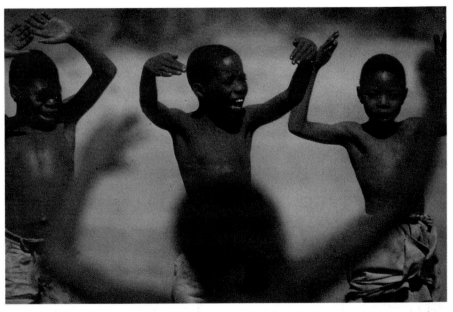

◀ People tend to form cohesive groups on their own. Most of the schoolgirls on the edge of this group are facing toward the circle formed by those who are seated. The uniform colors throw the angles of arms and legs into relief. Photo by Thomas Hopker.

▲ With depth of field limited by a 180mm lens, the photographer focused on the individuals facing him and used the foreground as a frame.

▼ This group is unified by a strong red background. Photo by John Garrett.

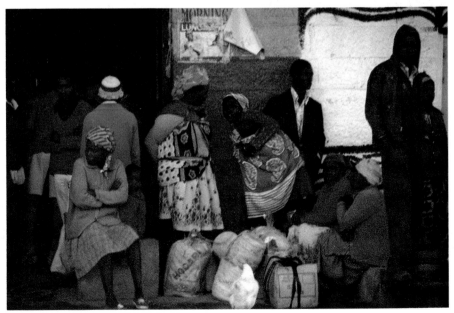

Photographing Your Children

One of the most rewarding pleasures of a parent can be photographing your own children. With a subject as fascinating as a growing family, you can build a memorable record with any camera.

Between birth and school age, a child is seldom left alone. There are many photographic opportunities. Playing, bathing, eating, dressing, even sleeping may not seem very photogenic, but they are important childhood activities. For a complete record, don't neglect the moments of frustration, irritation and tears, too. These emotions are as interesting as the fun and laughter.

Because children have boundless energy and are usually in motion, you may have to use a fast shutter speed to stop action. The aperture will have to be correspondingly large, which reduces depth of field and requires accurate focusing. Using a large aperture is an advantage when you want the background out of focus. This is helpful when the subject is in a room cluttered with toys and household paraphernalia, and you don't have time to find a camera angle that puts him against a less cluttered background.

It is helpful to use a camera angle from above or below the child. This helps eliminate these unwelcome distracting elements. A carpet, lawn or sky is an excellent background for your small subject. In addition, a high viewpoint reflects the way you normally see the child.

THE RIGHT MOMENT

A child's life revolves not only around his house and yard, but also involves trips to the store and journeys by bus, car and plane that are seldom regarded as photogenic situations. Also, people tend to put their cameras away as soon as it begins to rain. But what could be more evocative than a picture of a child with his nose pressed to a steamed-up car window, with rain pouring outside? Also, there is always a special quality about "first time" pictures, such as the first time your child rode a two-wheeler, caught a fish or rode a pony at the park.

Special occasions that involve careful planning, like birthdays or picnics, are photogenic. Surprise is a positive reaction that registers clearly on a child's face. The photographer who can capture real surprise on the face of a child has begun to master the art and technicalities of photographing children. A photograph that records strong emotion in a child is an appealing and worthwhile addition to your collection of people pictures.

Always keep a camera handy. It is easy to say you'll take some pictures tomorrow when you are less busy, or after the child's bath when he looks best. However, you may miss an opportunity that will never occur again. Every day your child gets older and one more day passes, never to be repeated.

DAY ONE
▲ Helmut Gritscher planned to make a complete photographic record of his son Thomas. He asked a friend to make this photo of father and son on the first day.

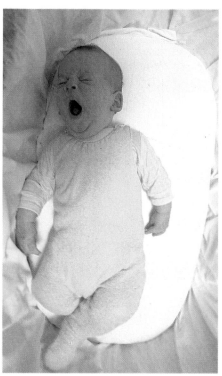

FIRST EXPRESSIONS
▲ With the subject still immobile, what you must hope for is the random smile or yawn. Gritscher exposed this one from above, using fill flash, daylight and a 21mm lens.

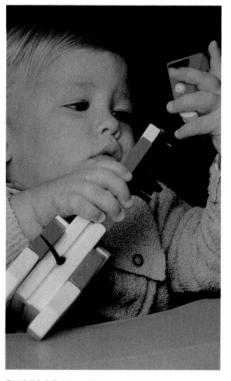

PHOTOGRAPHING A TODDLER
▲ At this age your first problem is to catch the subject. With Thomas concentrating while sitting in his chair, Gritscher used a 90mm lens and bounce flash.

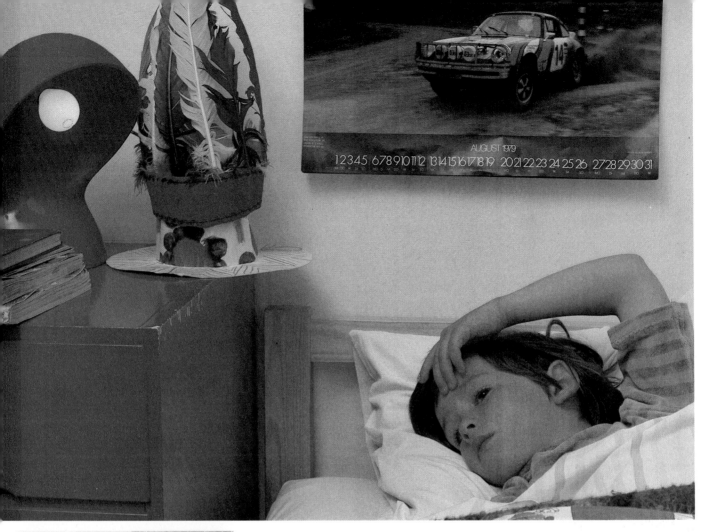

YOUR CHILD'S BEDROOM
▲ By the age of five, your child's room already reflects his character, and becomes a good background. In fact, Thomas is only part of the picture here. Bounce flash minimizes the effect of the bedside lamp.

THOMAS WITH HIS BROTHER
▼ When photographing your children together, wait for the moment that best shows their relationship. Here Thomas is absorbed in a game while his younger brother looks on. Fill flash supplements daylight and the pale tabletop reflects light into their faces.

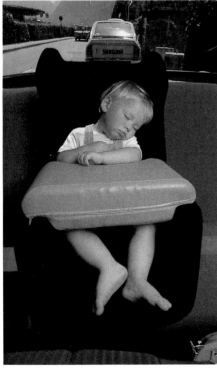

ASLEEP IN THE CAR
▲ Because toddlers spend much of their lives asleep, take typical shots during those peaceful moments. Gritscher used flash bounced from the car roof. A 21mm lens distorted perspective.

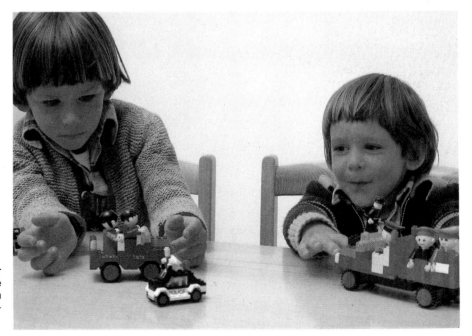

YOUR CHILD AND THE CAMERA

Many children are fascinated by cameras, but others may be camera-shy. They may curl up, hiding their faces behind arms and hands, and the more coaxing you do, the more shy they become. Bribery is one way to get around the problem, though a simpler solution is to make use of whatever reaction presents itself at that moment. If he hides his head, photograph what you see. It may be a funny photograph.

A candid photo of a child usually says more than a posed photograph. Friends and acquaintances may not be able to see this, but it is important to remember that you are making the photographs for yourself, for the rest of the family, and for the children themselves when they are older.

TECHNIQUES

The photographer-parent has to be aware of every opportunity for a candid. Obviously you can't carry a camera around your neck all the time, but you can keep one handy, on a shelf or other convenient location. "Grab-shots" usually make the best child photographs, but they will only be successful if you are familiar with your equipment so you can make exposures quickly.

If you do not have an automatic-exposure camera, have the camera pre-set for good exposure for normal lighting conditions in your home. Or, keep a small automatic electronic flash attached to the camera. If you also pre-set the lens for an average subject distance such as 10 feet (3m), you can work quickly when the opportunity arises.

COMPILING AN ALBUM

A family album can be more than just a convenient place to store a random selection of photographs. Instead of displaying the prints in the order they come back from the lab, use the pages to tell a story. For example, show a series of one of your children at different ages but doing the same thing, such as sitting at a desk or riding a rocking horse.

Another series might show different children as they take an interest in the same toys at a particular age. This would illustrate the similarities or differences in their approaches to things. One child may suck his finger while another plays with his hair. Put photos of these habits together on one page. They are tangible links with the past, a forceful reminder of childhood even when the habit has long been forgotten.

CLOSE-UPS
▲ With a long lens, John Garrett peeked under his son Nicholas' hat and into his thoughts. The shadow from the hat demanded careful meter reading to hold facial detail.

Photography can bridge the generation gap, too. Grandchild and grandparent may have 50 years separating them, but they are of the same family. Look closely at your old family photographs for likenesses and mannerisms that persist through generations. Emphasize this with posing and lighting similar to the old photos.

Family links and likenesses can also be emphasized by techniques like multiple exposure or multiple printing from a carefully thought out series of photographs. You can make combination prints from portraits showing the same child at different ages.

You can also print photographs of different children of similar ages on the same piece of photographic paper. The result may show likenesses that you could never see when the individual exposures were made. Without photographs, it is all too easy to forget what your children looked like during their development.

SPONTANEOUS PHOTOGRAPHS
▶ Even an experienced photographer can miss part of the subject on the spur of the moment. Although he didn't get all of the subject's hands and feet in the frame, John Garrett's photo shows the child's gleeful mood. A slow shutter speed conveys the feeling of quick movements.

PLANNED SITUATIONS
▼ Although this was set up in the shade of a tree with the cat as a prop, Nicholas and his young brother have by now forgotten the camera.

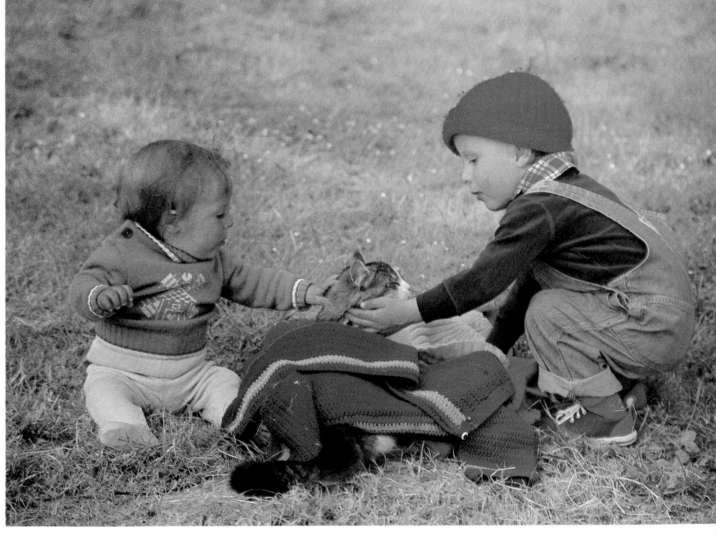

Moments in a Baby's Life

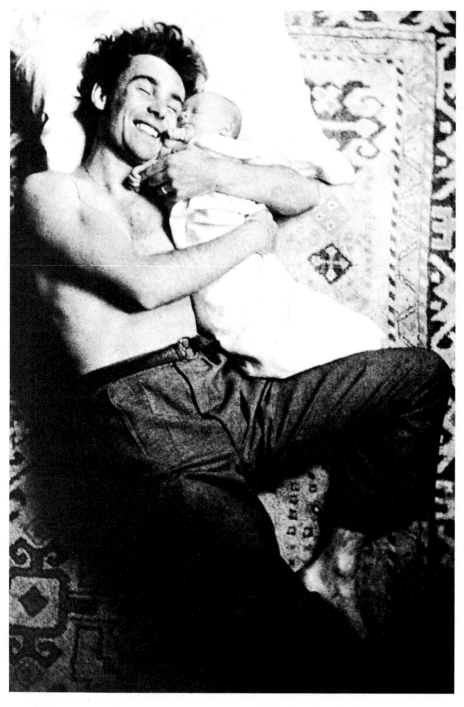

A baby's life is full of memorable moments too soon forgotten. A pictorial record, especially if the photographs are imaginatively done and technically successful, is a rewarding and enduring reminder of the child's earliest days. The most important thing to remember about photographing babies is that *you* must be ready for *them*. Babies cannot deliver smiles on demand or look into the lens on request, so you must be ready at all times.

▲ Photographer Jacques-Henri Lartigue took this picture looking straight down, capturing the joy of a young father.

▶ Strong highlights and shadows are created by light streaming through a tall window. Photographer Elliot Erwitt has described it as a snapshot, referring to its chance composition and lighting. His skill was in recognizing the right time to press the shutter button—the moment of eye contact between mother and child.

When photographing babies, your inhibitions will only hinder you. Be prepared to clown around, shake rattles, get down on all fours—anything to catch the baby's attention and the special expression that makes a great photograph. Don't enjoy yourself so much that you forget the most basic rule of all portrait photography—focus on the eyes.

CANDID PHOTOGRAPHS

For candid photographs, a lightweight 35mm SLR camera is best. But if you don't have an SLR, use a camera you are familiar with. Don't miss a once-in-a-lifetime photograph because you are struggling with unfamiliar controls on a new camera. Keep the camera loaded with fast color or b&w film and set a shutter speed, such as 1/125 second, that is fast enough to stop most movement. Then, when the opportunity occurs, shoot.

PLANNED PHOTOGRAPHS

For planned photographs, have everything ready in advance—not just the camera, but lights, background and diversions to entertain the baby. A tripod and cable release are especially useful because they leave one hand free to attract the baby's attention. A helper can do the job, but make sure you have only that one additional person in the room. Too many people may confuse the infant.

Unless babies are very young, they will be content and responsive for only 10 to 20 minutes. Do not persevere once they have lost interest or when they are tired or

hungry. Try instead to photograph in short sessions at appropriate times. Take a good selection of photographs during this responsive period.

CLOSE-UPS

Close-ups present special problems. Young babies are so small it is hard to fill the viewfinder with the whole body, let alone a face or hand. If you have a 35mm SLR, a lens with a focal length of between 85mm and 105mm is ideal, although the standard 50mm lens also gives good results unless you get too close.

LIGHTING AND BACKGROUND

Soft, natural lighting is the best kind: Direct sunlight produces unhappy, contorted faces and harsh shadows. Flash can upset the baby. With color film, avoid bright-colored surrounding surfaces or backgrounds because reflected light may cause the baby's skin to have a green cast due to grass or appear lobster red against a red chair.

Cream and white are ideal background colors. With light-skinned babies, experiment with dark neutral colors. Photograph dark-skinned babies against light backgrounds.

When working outdoors, stay in the shade or use bright sunlight as back or side light. Indoors, many professional photographers prefer to use fast film and available light from a window.

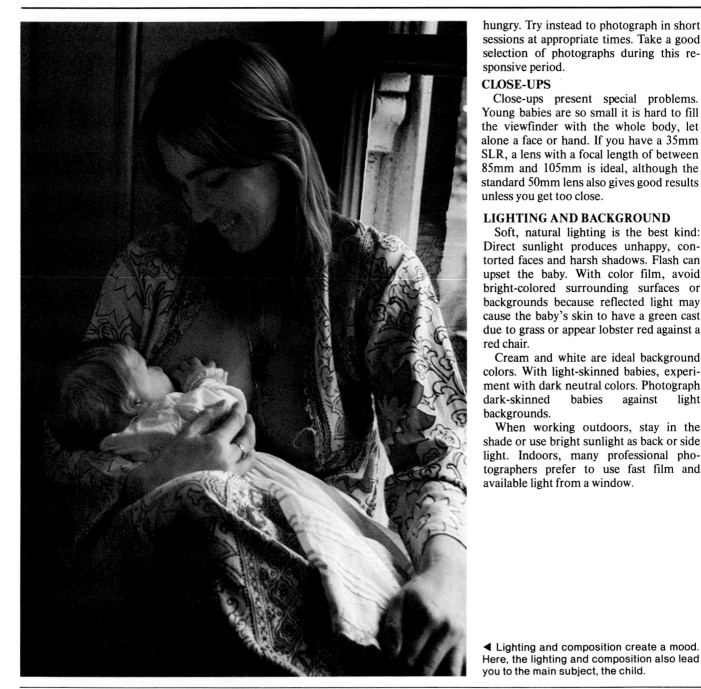

◀ Lighting and composition create a mood. Here, the lighting and composition also lead you to the main subject, the child.

KEEPING A RECORD

At no other time do humans undergo as many changes as during the first year. An alert parent can document on film a whole series of firsts—the first feeding, the first smile, the first crawl. Know what to look for and when, and how best to photograph the moment. Babies progress at different rates, but all will eventually do similar things. Your albums will be more interesting if you vary the shapes and sizes of the photographs.

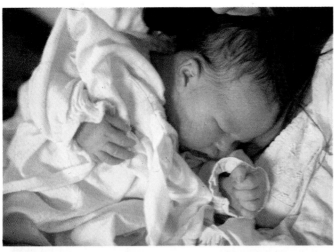

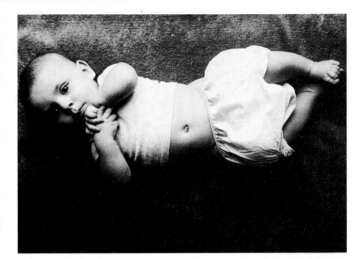

▲ Top left: A photograph of a sleeping one-day-old is made more interesting by including crumpled clothing. This close-up was taken with a standard lens on a 35mm camera by C. Shakespeare Lane.

▲ A dark towel used as a background is a pleasant contrast to the smooth skin of a young baby. Notice the impact of directional lighting. Photo by C. Shakespeare Lane.

◄ Showing obvious pleasure, this baby responds to a diversion. Photo by Richard and Sally Greenhill.

▼ An expressive photograph, this baby's face reveals the full intensity of his anger and frustration. Photo by Malcolm Aird.

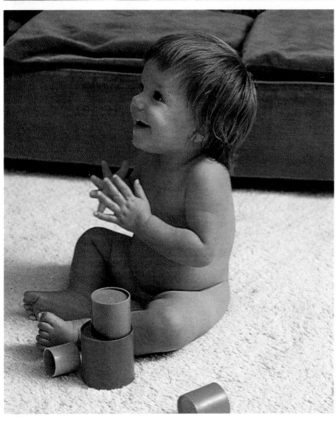

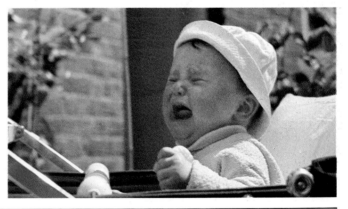

UP TO 4 WEEKS
Often red-faced, wrinkled and too small to fill a viewfinder, new-born babies are best photographed with a parent or other adult.
● For a first mother/baby picture, hold the camera above the subject, perhaps while standing on a chair, looking down as the mother nurses the baby.
● For a first father/baby photograph, contrast the fragility of the infant with the father's strong, masculine arms.

4-8 WEEKS
The baby's eyes begin to focus and, although he looks around, his head must still be supported. If you speak softly to him, he may lift his head.
● Lay the baby on his stomach on the floor and take pictures from the front and side at floor level. For a different angle, have someone hold the infant close to the side of a bed and hold the camera just below it, looking up.
● Drape a plain sheet over an armchair and place the infant in a corner.

8-12 WEEKS
Now the baby begins to smile and likes to be propped up to see what is going on. He is more easily entertained by movement and his facial expressions are more changeable and varied.
● For a profile of the mother and a full-face portrait of the baby, pose the mother with her back to the camera with the baby held over her shoulder. If the mother tickles the baby's toes, you may capture an enchanting smile.

▶ Available light from a window behind the subjects gives a soft, natural look to a profile of a mother and newborn child. Photo by Anthea Sieveking.

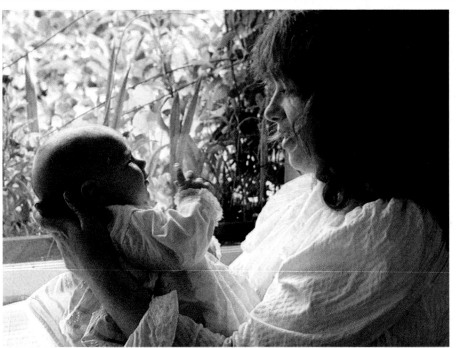

▼ A transparent plastic tub makes bathtime photographs easier because it avoids the need for an overhead view. This photograph was carefully planned with a pre-arranged camera position and lighting, and a plain white background.

▼ Below right: Proving that memorable baby photographs do not have to be of happy faces, this once-in-a-lifetime image catches an anxious look. Photo by Anthea Sieveking.

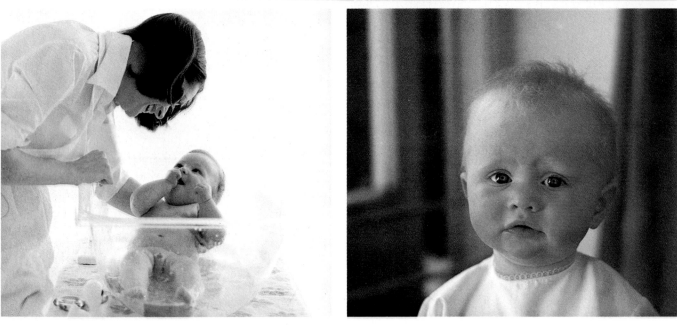

12-16 WEEKS
The baby begins to stretch his legs and can support his head better when propped up. He also chuckles and gurgles readily. His attention is easily attracted by sounds.
- Have mother sit out of sight on an armchair, holding the baby up so he looks over the back.
- Photograph the baby stretching his legs in a baby seat hung from a hook above a doorway.

16-20 WEEKS
The baby becomes aware of his hands and is fascinated by his ability to clutch and curl his fingers around objects.
- Photograph the baby clasping a new toy or shaking a rattle. Alternatively, show his tiny fingers clutching an adult finger.
- If you haven't taken a profile of the baby yet, try now. Have the mother hold him up high so she is out of sight. Or take a profile of mother and baby facing each other.

20-32 WEEKS
The infant tries to sit up unsupported and becomes aware of his feet. Mirrors are fascinating.
- Try to catch the baby nibbling his toes—perhaps a spot of honey on the toes will encourage this.
- Photograph the baby sitting up unsupported. Have a helper nearby in case of a spill.
- Using natural light, try a shot of the baby catching sight of himself in a mirror. Position yourself to one side so your reflection doesn't appear in the photograph.

▶ A tender and typical photograph of mother and child made by Anthea Sieveking.

▶ Far right: By placing the baby under a tree, the photographer not only avoided harsh sunlight, but provided a diversion. Photo by Anthea Sieveking.

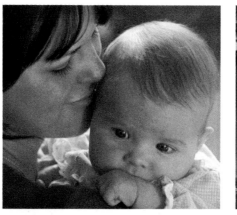

▼ Documenting the first moments of life requires careful planning and permission of the hospital. Take a series of pictures to record such an event. Photo by Homer Sykes.

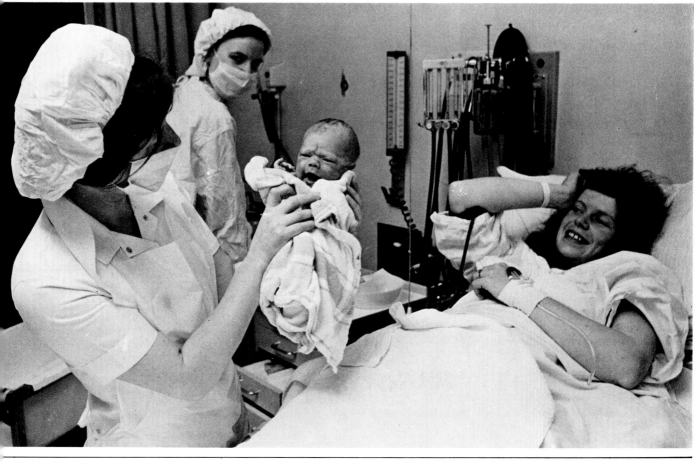

32-36 WEEKS
The baby starts to crawl. The new-found mobility opens up a curious and fascinating world.
- Be prepared to drop what you're doing and grab your loaded camera as the baby discovers noisy saucepan lids, cabinet doors and other novelties.
- For a planned crawling shot, set up all equipment in advance. Place a new toy in the direction you want the baby to crawl and make lots of exposures as he "dashes" for the toy.

36 WEEKS TO 1 YEAR
Learning to stand is a major preoccupation. The baby is now larger and better fills the viewfinder, so it's a good time for close-ups.
- For a photograph of the child standing, have a helper hold something shiny or noisy just out of reach but above the child's head to encourage him to stand. If you have no helper, dangle the object yourself and work with the camera on a tripod, using a cable release.

1 YEAR
An infant's first birthday, particularly if there's a party, offers plenty of photographic possibilities.
- Blowing out candles on the birthday cake is a picture helped by the fact that all children love flickering lights.
- Take advantage of this age group's lack of inhibitions to get unposed photographs of the baby and guests. Make lots of exposures to catch changing facial expressions.

Photographing Toddlers

Between the ages of one and five, a baby grows into a communicative person, full of curiosity. Life is an adventure and the days are full of fun. It is an age of discovery. For the discerning photographer, this period provides a wealth of material.

BE PREPARED

Once a child is on the move, it takes more than a fast shutter and high-speed film to capture spontaneity. Opportunities come and go very quickly so you have to anticipate them and be ready. If you have children of your own, keep a loaded camera in a handy place so you can record those bizarre situations that only happen once, such as the "artist" after an introduction to finger painting, or the uninhibited toddler tackling an over-sized problem.

Your intent should be to capture an incident before there is time for the child to overact or become camera shy. Always be prepared to make plenty of exposures. This is important with children. You want to catch their unpredictable expressions and movements, and get them accustomed to the camera. The more they see it, the sooner they lose interest in it and return to the activities you want to photograph.

PLANNING A SESSION

Photographic sessions involving other people's children require advance planning. Decide whether you'll use color or b&w, slide or print film. Also consider lighting and location—indoors for formal portrait shots, outdoors for action shots and portraits with natural settings. Then, when the subject arrives, you can concen-

▶ Young children are perfect subjects for a picture series like the child's first few steps. Here the mother helped by calling the baby. Anthea Sieveking used a motor drive on her camera. But if you work fast, you can get good results without automation. The soft, even lighting is a result of multiple reflections of window light from white walls and the polished floor.

▼ Diffused lighting is ideal for child portraits. Outdoors, supplement light from an overcast sky by holding a white reflector close to the subject's face.

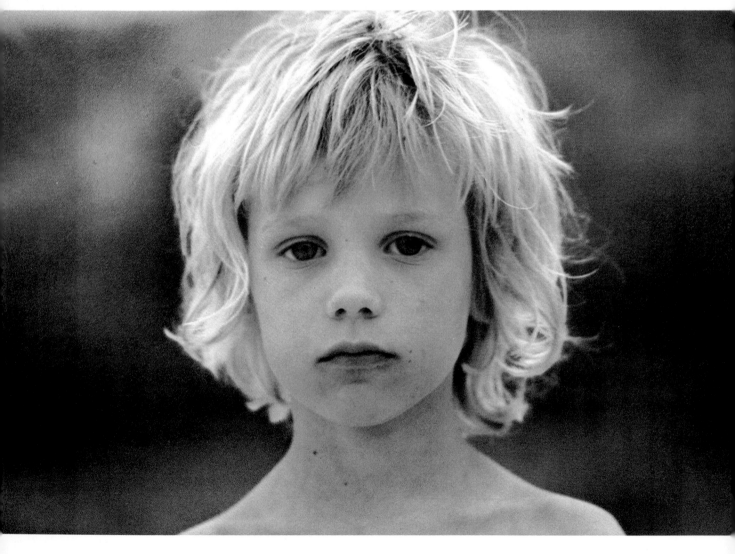

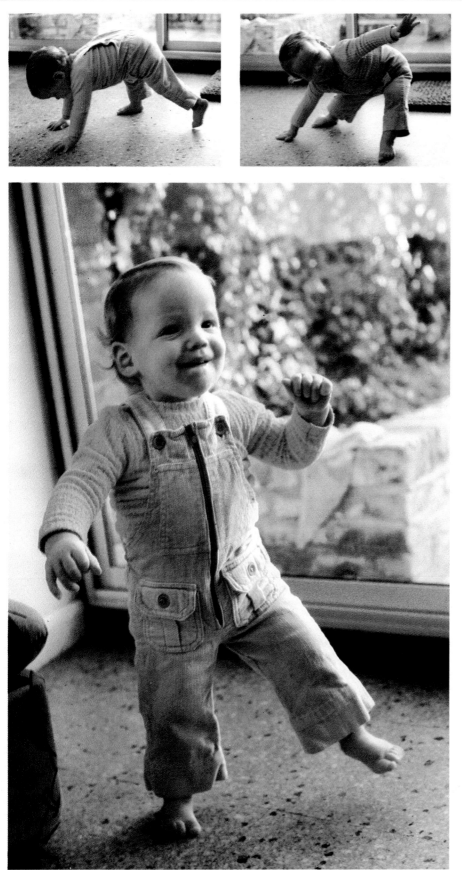

trate on creating photographs rather than on camera settings and lighting arrangements.

Have some snacks to give the child during any waiting periods. If the session never really gets off the ground, give up gracefully. Toddlers cannot hide their feelings when they are bored or unhappy.

You will probably enjoy the game of photography with the toddler as much as he will. A stranger often has an advantage over parent photographers because the child will almost certainly obey his directions. A parent behind the camera does not always get full cooperation.

LIGHTING

During summer days you should be able to take most informal indoor or outdoor photographs using available light and slow-speed film. In dim conditions, use high-speed film and white reflecting surfaces.

High-speed b&w or color negative films can usually be *pushed* enough to give acceptable results under low light. This is done by setting the camera meter to a higher than normal film speed and processing the film differently. You can find information on this technique in film processing instructions. Because an increase in film speed means adjusting processing time for the entire roll, this technique cannot be applied to individual frames.

Lighting for close-up portraits is very important. For effective results with young children, use diffused light such as you find outdoors on hazy days or in areas of open shade on sunny days. You can create almost shadowless light indoors by using bounced flash.

KEEPING THE CHILD STILL

A child's first birthday usually begins the age of mobility. This is not a problem for agile photographers willing to make numerous exposures. It is important to take the camera down to the child's level. But a less tiring and more economical approach is to encourage some relatively still moments.

The easiest way is to sit the child on a low stool or tricycle, or in a high-sided container such as a shopping basket or a card-board box. Find a suitable place for the "seat." The location should be free from clutter and have an uncomplicated, natural background so the image is simple. Impact is created by the subject rather than the surroundings.

Pre-set the camera and position yourself at the toddler's eye level. Then place the child in the desired position and shoot quickly. By the age of two, toddlers are more predictable and less likely to move out of range before you have made the exposure. The problem of keeping them still for a photograph diminishes as they become engrossed in what you are saying, or in toys and creative play.

CLOSE-UPS

One of the easiest ways to make candid close-ups of young children is to wait until

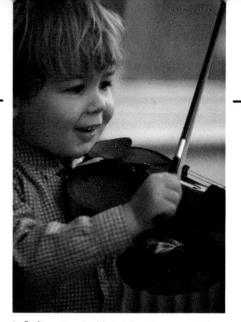

▲ Soft, natural sidelighting from a window illuminated this violinist. Photo by Michael Boys.

▶ Direct sunlight through a window requires careful composition to avoid conflicting shadows. Anthea Sieveking set up the blocks and waited until the boy was engrossed.

▶ Gary Ede made this exposure during a quiet moment of concentration.

▼ You need not always show your subject's face. This boy, engrossed in his own world, did not notice the photographer.

they are occupied. A two-year old may sit happily for several minutes putting shoes on the wrong feet or reading a book upside down. An older child may become totally absorbed in drawing a picture. During such moments, you should have no difficulty making expressive close-ups, especially if you have a telephoto lens that allows you to keep your distance. If the activity is interesting and colorful, you may want to document it with a series of photographs taken at different angles and shooting distances.

NURSERY SCHOOLS

Nursery schools offer many opportunities for candid photography. Visits should be arranged in advance so both staff and children are prepared for the distraction. Plan to spend a lot of time with the chil-dren. The results will probably show a gradual progression from conscious poses with the children playing up to the camera, to the intent expressions of youngsters preoccupied in their own activities.

Whenever possible, plan lighting and backgrounds. If a distracting background is unavoidable, use a large aperture to blur shapes. Remember that the camera lens will distort facial features if you move in

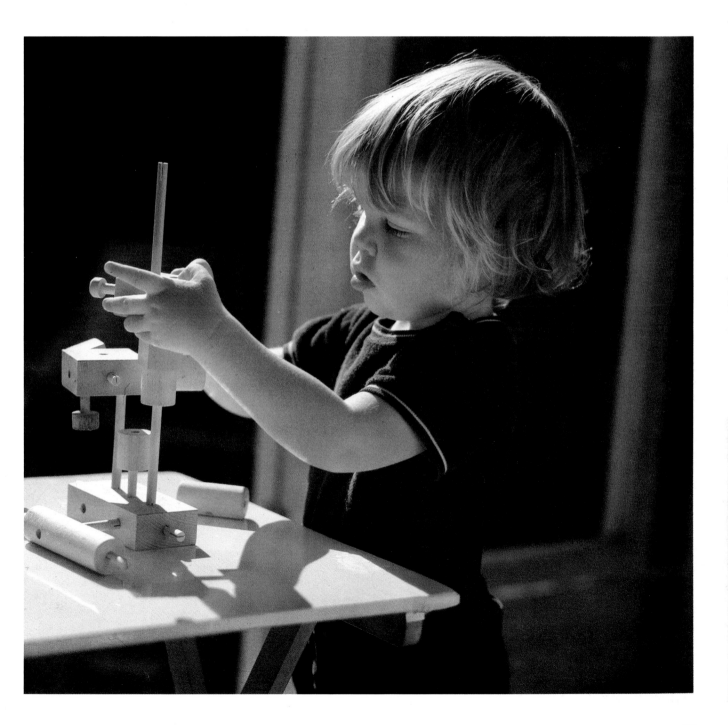

too close. A distortion-free distance with a standard 50mm lens is 3 feet (1m) or longer.

A good way to obtain bold close-up photos is during printing, when you can selectively enlarge one part of the image.

OUTSIDE ACTION

There are many opportunities for photography outdoors, as children rush around with toys and tricycles, or romp in sand and water. Action shots on a swing or merry-go-round, candids of make-believe games, and studies in contemplation are fun to photograph.

Action photographs almost always require fast shutter speeds to keep the subject sharp. Remember that it is easier to prevent blurring if the subject is moving toward or away from the camera, and most difficult when the subject is moving across the field of view. If you have to use slower shutter speeds, plan your viewpoint accordingly.

Accept that dirty hands and faces, disheveled hair and rumpled clothes are all part of these outdoor photographs. Producing a washcloth or comb before you press the shutter button is a sure way to kill spontaneity and ruin your chances of successful photographs.

◄ You'll find lots of color and activity at parties. Outdoor shade gives a soft light that tones down clashing colors. No shadows complicate the image. Photo by Anthea Sieveking.

▼ Seaside photographs are usually bright because of light reflected from the water. Always use a lens hood and expose for the subject. Photo by Fiona Nicholls.

▼ Showing your child how to use a camera may make him a more willing subject and provide some interesting candids. Photo by John Garrett.

► Some of the best portraits are candids. With a high viewpoint and a wide-angle lens, the photographer included the child's activity and samples of her work.

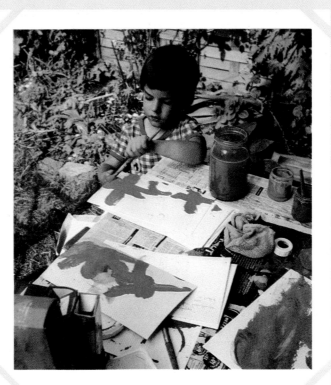

▼ With a long lens, you can keep the camera at a distance from self-conscious children. Set up for the shot and then call out to attract attention just before you press the shutter release. Photo by Tony Boase.

▼ A big ice cream sundae looks bigger through a wide-angle lens used close up. Photo by John Watney.

Photographing Schoolchildren

Starting school is a big adventure for every child. It also marks the beginning of a new era for the photographer. Your challenge is no longer the smallness of the baby or the unpredictable energies of the toddler. No longer will sticky fingers reach out to grab the camera lens and block the view. The new problem is the independence of the young schoolchild, who has better things to do than wait around to be photographed.

As soon as a child gets established at school, his interests and social activities broaden. Friends rather than parents begin to take a leading role. Between the ages of five and ten, there will be fewer "firsts" for you to photograph, and you will have less opportunity to get spontaneous pictures.

FORMAL PORTRAITS

If the child has to wear dress-up clothes for an occasion such as a wedding, a dress rehearsal is an excellent opportunity for a formal portrait.

Lighting—The degree of formality you achieve in a portrait of a five-year-old depends very much on the lighting and the props you have. Although some people use the standard photoflood setup—main, fill and hair light—a more modern approach for indoor portraits uses an umbrella or bounced flash as the main light source. Both give soft, almost shadowless light that complements a young face and allows the subject some mobility. This is an advantage when you photograph a fidgety child. Flash bounced from a white ceiling is best for pictures of children wearing glasses.

Composition—Though lighting is the essence of a good portrait, another important consideration is composition. Unifying elements of the photograph, such as colors, shapes and lines, create a well-balanced image. Even in a portrait of a five-year-old, shapes and lines can be created with simple props such as a desk or chair, and with relaxed poses. Position the child at an angle to the camera—the body should never be straight-on like a passport image or "mug" shot. Keep his arms and hands on the same plane as his body. If they project toward the camera, they will seem oversized and distorted.

During the session, build up confidence by chatting about what you are doing and why. If you make the whole thing interesting and a little scientific, you should be able to get good images from the toughest of subjects. As you are talking, keep watching and focusing so you can shoot an animated expression without delay. A shy child is often photographed more successfully from a distance with a long focal-length lens.

Negative films are the obvious choice for portraiture because they are easy to print, crop and enlarge during printing. If you do your own darkroom work, make

▼ ▶ For a portrait session with his own children, Malcolm Aird arranged a simple lighting setup consisting of a tungsten-halogen lamp with an umbrella on one side and a reflector on the other, as shown at right. He used a 55mm lens and plain background for this simple group portrait. His biggest problem was getting all the children to cooperate at the same time.

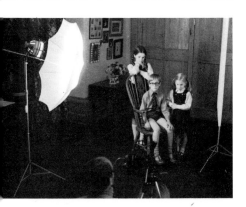

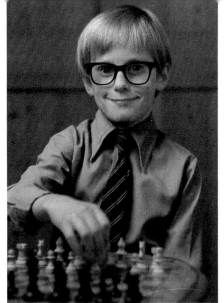

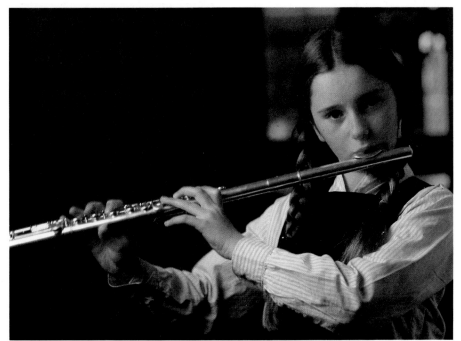

Individual portraits of the children are more relaxed. For these, he used an 85mm lens.

▲ Top: it would have been uncharacteristic to photograph the boy without his glasses, so Aird had to avoid reflections from the lamp. Lights bounced from the ceiling accomplished this.

▲ Here, a complex background is reduced to simple shapes because depth of field was minimized. The photographer exposed carefully for the face and avoided reflections from the shiny flute.

◀ An intricate background pattern may merge with the subject. In this portrait, the subject's light hair and blouse create sufficient separation from the background.

contact sheets and work with these first. Or, on prints from the lab, use L-shaped masks to choose the best framing for selective enlargement.

HOME ACTIVITIES

Portraits don't have to be formal poses. You can also *create scenes* with the children as models or actors for a photographic series.

Children, particularly young girls, enjoy dressing up and playing with makeup. Set the scene against a plain background and watch the "theater" through the viewfinder as the "actors" dress themselves in assorted garments. You can use clashing colors to add to the drama. The series will be more interesting if you can vary distances and camera angles. Bounce flash and an extension cable release are invaluable for this.

Playing with makeup often involves the use of mirrors. It is not difficult to record both the real and the reflected image in the photograph, provided you frame the shot with care and focus *either* on the child *or* on the image in the mirror. Once you've selected the best composition, check the mirror image to be sure it does not show your reflection or an undesirable background.

OUTDOOR ACTION

Outdoors, you can photograph children on bicycles or roller skates, for example. A picture series of such activities requires a shutter speed of 1/250 second or faster, and a photographer with quick reflexes.

Children with pets are attractive subjects. Feeding, grooming and playing with a cat, dog, rabbit or other pet produce plenty of appealing pictures—especially if you shoot close-ups.

SPECIAL EVENTS AT SCHOOL

As soon as a child goes to school, both he and his parents become caught up in the organized activities, such as Thanksgiving and Christmas parties, plays and concerts and dance classes. Caroling, plays and parties make excellent photographs for use on Christmas cards.

Photography of these occasions can be approached in several ways. Many photographers try to avoid flash and shoot by available light. Often this means pushing a fast negative b&w film to a faster speed. You can do this if you process your own film or have it done by a custom lab. The instructions are usually in the data sheet packed with the film.

Stage performances are always better photographed relatively close up, preferably from a position on the stage itself. Attend the final dress rehearsal for these shots, and supplement those exposures with others made during an actual performance. Remember that when actors, particularly young ones, are photographed from a distance, they often look lost on a vast stage.

When photographing theatrical events in color, use tungsten-balanced film. Daylight film renders color well in daylight or by flash, but does not give good color with theater lighting. The photographs show an overall warm cast. Even tungsten films may show a warm cast.

Some correction for color defects of this kind is made automatically during machine printing of color negatives. In this case, photographing with color negative materials is better than working with transparency films because there is no way to alter color in transparency materials.

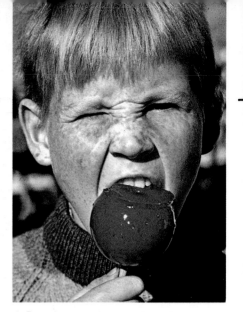

▲ Posed portraits may show off your children but it is often candid snapshots that reveal their real personalities. Photo by Constantine Manos.

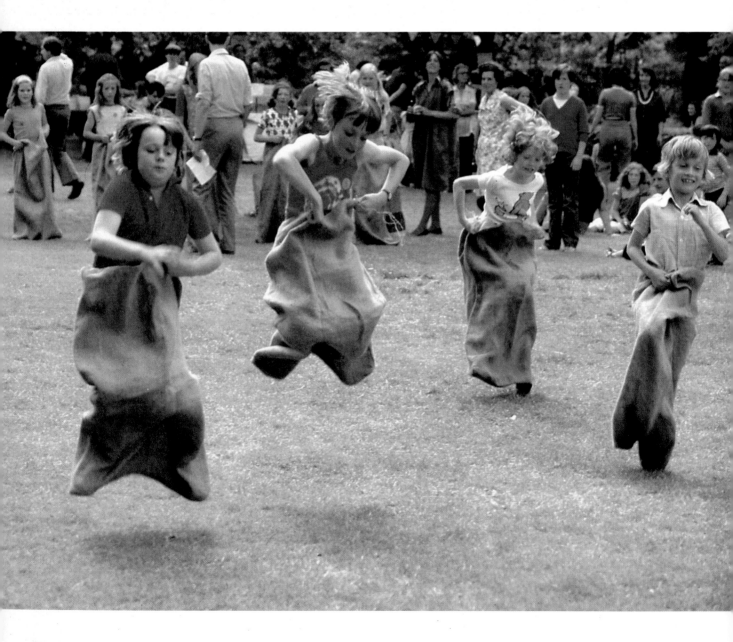

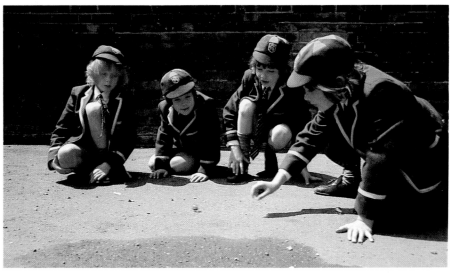

◄ Strong sunlight is not ideal for photographing people. Shadows may obscure their expressions. Here the boys' caps shade their faces, but the midday sun is reflected from the ground to fill shadows with soft light. Photo by Clay Perry.

▼ When using daylight and candlelight in the same photograph, remember that one will cause a color cast. Using daylight film, Michael Hardy balanced the light sources carefully. More window light would have overpowered the effect of the candles. The warm glow on the girl's face is appropriate.

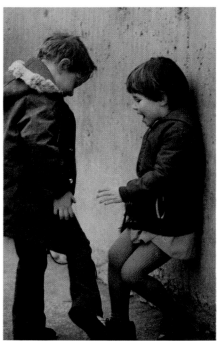

▲ As children develop new friendships, the playground becomes their private world. Photo by Michael Busselle.

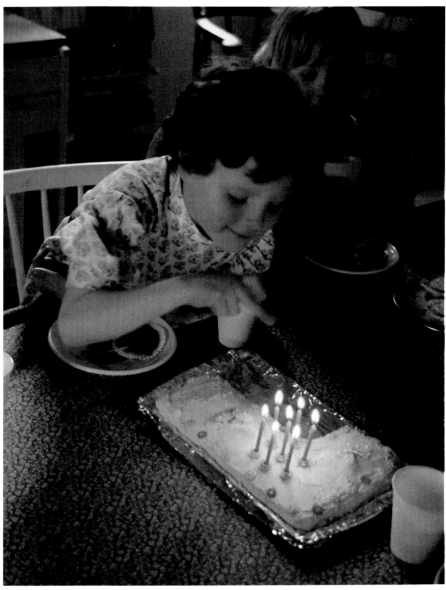

◄ For action shots on an overcast day, choose a film that allows you to use fast shutter speeds. Anthea Sieveking used a shutter speed of 1/500 second and waited for the moment when most of the racers were in the air.

Children at Play

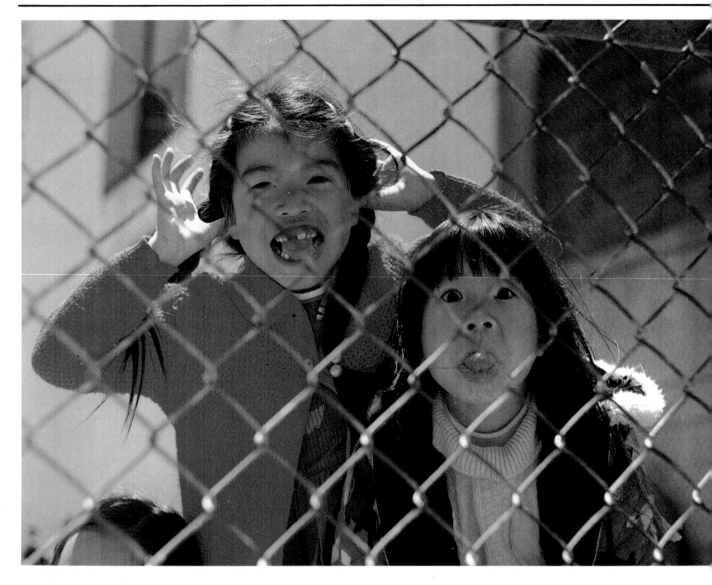

To photograph spontaneous children's games, adults must become "part of the scenery." Children learn about the world by playing. They really concentrate at it and, like grown-ups, dislike interruptions. The secret of becoming accepted is having a respectful attitude and approach.

The golden rule is to make friends at the child's pace. Never be pushy. A friendly, open and unhurried adult, genuinely interested in what the child is doing, will be accepted quickly. Children react to anyone, especially to a photographer who is interested in what they are doing. The reaction varies according to the age and number of children.

Younger children, especially on their own, can be shy when a stranger, or even someone familiar, has a camera. Approach them through an adult, perhaps a parent or play leader, and wait until the child talks to you. It is much easier to make friends with children who have seen someone they trust being friendly with you. Groups of young children, aged six or less, accept strangers quickly. There always seems to be one individual who wants to make friends with everyone.

It is easier to make the first approach with older, more mature children if you are prepared to answer innumerable questions. Patiently explain what you want to do and why. Wait a little longer once the questions have subsided before making any exposures. Let the child forget the camera. Failure to do this encourages the ham actor in every child.

The most difficult children to deal with are ages 8 to 11 in a group. Produce a camera in front of them and there will be a chorus of, "Are we going to be on TV?" or a gallery of funny faces. This is okay if you want photographs of funny faces, but if not, you must wait until they begin to ignore you. When they lose interest in you, they'll start to play. Some will hang around wanting attention. Walk around and show interest in something else when this happens.

If you see a possible picture, stop and wait a moment. Focus on the children you want to photograph and then turn your back on them. Turning your back prevents them from becoming self-conscious. It also clears a space in front of the subject because any "hangers-on" will want to stand in front of the photographer. Wait another moment, then turn around and make the exposure.

This trick works only a few times. After that, it becomes a game in which the "hangers-on" run around trying to guess who is going to be your next subject.

Children react to the camera in different ways. Their attitudes are influenced by how you approach them.

◀ Make friends at the child's pace if you want to become part of the child's world. If you appear suddenly with a camera, shy children will withdraw or hide. The bolder ones will ham it up. Photo by Pierre Jaunet.

▶ Younger children should be approached through an adult they trust. Talk to the grown-up first so the children can see you are a friend. Photo by Anthea Sieveking.

▼ Older children can often be approached directly. Sometimes a child will sense what you want and will "perform" for the camera. Photo by P. Goycolea.

It may be to your advantage when children show off for the camera. Sometimes children can sense what the photographer wants. If they decide to be cooperative, you may get every kind of picture you could possibly imagine. If they decide not to cooperate, you have two choices—wait or make exposures of them acting for the camera.

Sometimes, children between 8 and 11 can be the easiest children to photograph. If they are involved in an energetic game, like swinging on a rope tied to a tree, it is difficult to distract them.

Very small children deal with the camera in a different way. They seem to know exactly when the shutter is about to be released. If they don't like you, they will turn away and spoil the picture.

WHERE TO FIND CHILDREN

It isn't always easy to find places where children can play freely, especially young children. Obviously, it is an advantage if you have children of your own to photograph. Even if they have become bored with being photographed, they are likely to have friends who don't mind.

You can find children playing in these places:

- **Public parks and gardens** are excellent. On weekends there are often as many adults as children around.
- **Nursery schools and day care centers** cater to children of many ages. Check the Yellow Pages or local directories for those in your area and find out which have the best facilities for photography. Try to locate one with an outdoor play area or a room that gets plenty of daylight.
- **School playgrounds** are occupied at specific times. Visit the school principal or other official before taking pictures on school property. These are difficult places to photograph play activities. They are often crowded. The children are usually self-conscious and want to play fast games.

▶ Most children love water. Once they become absorbed in what they are doing, they won't notice you. Photo by A. Howland.

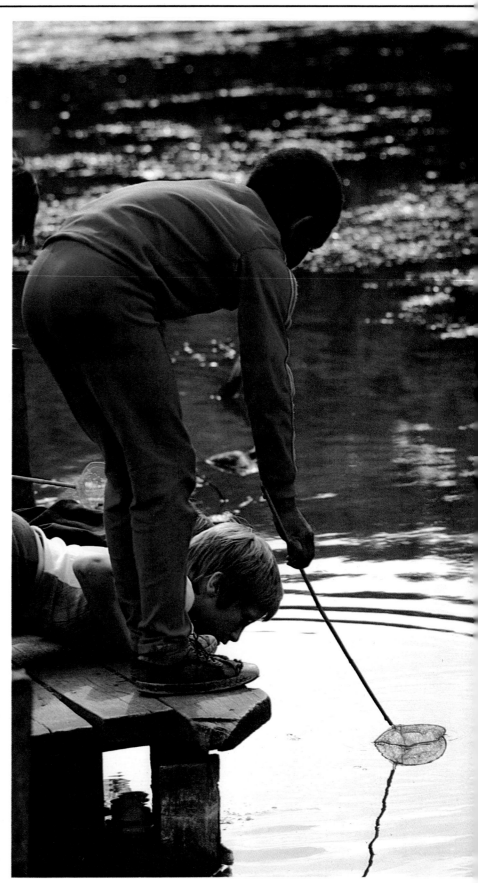

Children often play by themselves. The game may exist only in the child's mind. Regardless, the expressions are usually interesting.

▲ Swings suggest action, but here the isolation of one small boy is emphasized by the apparent stillness of the swing and the open landscape. Photo by Tom Nebbia.

◀ Far left: Children love hanging upside down. For a strong image, use a medium telephoto lens and fill the frame. Photo by C. Shakespeare Lane.

◀ Dress-up shots are irresistible. Choose a plain background to draw attention to the clothing, which is the source of the fun. Photo by C. Shakespeare Lane.

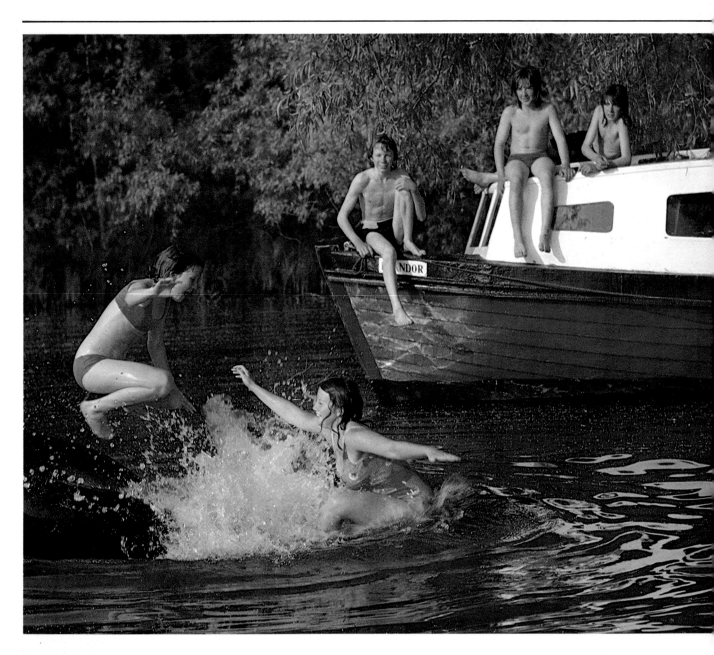

- **Water** is irresistible to children. Stand by a large puddle and the first child to come by is sure to make a splash. Hoses, buckets, streams and any body of still water are equally attractive.
- **Empty lots and construction sites** are hit-and-miss places to find children. If there are games going on, watch for stone throwing and swings made from old tires and ropes.

EQUIPMENT AND TECHNIQUE

You've located a suitable subject and background. What equipment do you need to make the best photographs?

Lenses—A 35mm SLR with a standard 50mm lens is best for children at play once you have become "part of the scenery."

A short telephoto lens of about 85mm to 135mm will fill the viewfinder with a child's face, depending on how far away you are. Use a longer lens when the subject is deeply engrossed in play. It brings you closer while avoiding distractions. Once you are accepted, it may be possible to use a 35mm lens for a larger view. Anything shorter than 35mm tends to de-emphasize the child as the main subject.

Film—Play usually requires medium or fast shutter speeds such as 1/125 second or faster. On a bright day outdoors, you can use ASA 100. Use ASA 400 when the sky is overcast or if the game is indoors in fairly good light. If the indoor light is poor, use a flash.

Backgrounds—These should be simple and clear. Let the background say something about the game—for example, that it is in the woods and not a park. Otherwise, make the background plain or out of focus.

If the background is very confusing, take advantage of your extra height by looking down at the child. This can make a simple background out of a floor or wall. Don't stand over the subject or he will appear hopelessly dominated. Never be afraid of kneeling down to the child's level to talk or make photographs.

Flash—If the natural light is bad, an automatic electronic flash unit mounted on the camera will help you get the shot.

SHARPNESS WORKS
◄ A shutter speed of 1/500 second may be required to photograph a very active group of children. Use a 135mm or longer lens to avoid intruding. Photo by Patrick Thurston.

AND SO DOES BLUR . . .
▲ You can capture a sense of motion by using blur. For this photograph, Richard Tucker used an exposure of 1/15 second while panning.

▼ . . . IF YOU SHOOT QUICKLY!
Children playing will not be interested in posing for you. Actions and reactions happen fast, so you have to work quickly. Using an automatic-exposure camera helps. Photo by Ken Schiff.

Children move too quickly for you to adjust a manual unit, and mounting camera and flash together makes them easier to handle. Flash lighting freezes fast, spontaneous play.

Camera Bags—You should not carry unnecessary equipment in your camera bag. Even an extra lens will feel heavy after a day of running around with children. Tripods are seldom, if ever, used to photograph children's play because the subjects move too quickly.

Be Ready—Try to meter or estimate exposure before shooting, but if there's no time, shoot anyway. You may never get that same opportunity.

People at Work

Foundries, workshops, factories and offices provide photographic opportunities. You might simply want to take pictures of friends at work, or you might want photographs of local businesses that you can sell.

Before photographing in any place of business, be sure you have permission. Contact the company's community relations or public relations office. If they don't have one, contact the foreman or manager. And be sure the security staff knows what you are doing. If an area is declared off limits, accept the fact. Wear a hard hat in designated areas.

LIGHTING

Inside many work locations, light—and sometimes the lack of it—can cause problems. Carry a sturdy tripod, even when using a small camera. Use available light when it suits the mood of the photo.

Use fast films when necessary. The increase in grain is not a problem if the final print will be no larger than 8x10 inches. Or, make big enlargements and use the grain for a special effect. Even so, a fast film is not necessarily going to eliminate the need for a tripod. When using a tripod, it generally makes little difference whether you are shooting at 1/30 or 1/8 second if the subject is still. Nevertheless, for work in dark locations such as a foundries, use a tripod to be sure of getting a sharp image.

When using daylight color film, think about the color and amount of light. When a factory or workshop is illuminated mainly by daylight from overhead windows, there is little to worry about. The light may be slightly blue, so use a skylight filter to counteract the bluish effect. When the area is lit with fluorescent tubes, use an FL-D filter to balance the source with daylight film. This filters out the bluish-green cast usually produced with daylight film.

Problems start when there is a mixture of light sources, such as daylight, fluorescent and tungsten light. The overall effect may be better if you turn the artificial lights off and use daylight alone or with flash to fill shadows.

However, such methods are not always practical. Be prepared for this potential problem by scouting the area before the photo session. Then you can bring the proper filters and film. Also be ready to compromise when necessary. For example, when you color-correct fluorescent light using filters, daylit areas take on an amber cast with daylight film.

LENS CHOICE

A telephoto lens is useful. It gives enough camera-to-subject distance for good portrait perspective and to keep you and your equipment away from sparks and debris. A wide-angle lens can help create an interesting viewpoint or give an impression of space. Out of 20 scenes, only two or three are likely to be candidates for a wide-angle approach, but a few can improve the quality of the whole series.

Offices may *seem* easy places to make photographs, but you soon learn otherwise. The clutter of desks, filing cabinets and wall charts can make an interesting scene too busy. Here, too, long-focal-length lenses can help you isolate the subject and suppress backgrounds. When there are white or light-colored ceilings or white walls, bounce-flash can be a great help for soft, even lighting.

Don't forget to look for still-lifes around the work area. For example, chunks of shaped metal or a line of clay pots ready for firing can make interesting compositions. If the subjects work with their hands, make close-ups of those hands at work.

THE SUBJECT'S COOPERATION

You will never be inconspicuous when you use a camera on a tripod, so tell people what you are doing and why. If you ask them to help you, they will probably be flattered and do it. If you think an area could be improved by cleaning or reorganizing, ask, "Do you think we should put this over there? Would that look better?" People will usually be very helpful if you give them a chance.

Ask subjects if they would like to comb their hair. The time this takes will give you a chance to get an accurate light reading, try out flash angles and set up your equipment. Take your time about final decisions. Look for the best viewing angle and check backgrounds through the viewfinder.

Observe work procedures and select a sequence for your exposures. Explain what you want and how important it is that the subjects remain still unless you are using flash. Tell them if the exposure is long so they will hold still long enough. If you are "directing" the subjects and talking to them, make the exposure just before they expect you to.

When using flash and ambient light with a slow exposure, tell the subjects. Many people move after a flash fires. If something goes wrong, such as somebody moving during exposure, say nothing. Just retake the shot.

Occasionally, you can illustrate a particular action by a double exposure. For example, complex meters and colored lights on a control panel could be combined with a face or a tool. Use half the calculated exposure time for each exposure—the two halves add up to one correct exposure. The potential results of this technique are worth a few experimental frames. Check the camera manual to see how to make multiple exposures with your camera.

When you are finished, thank those involved and move on. And if you promise people prints, make sure they get them.

Here's a list of some high-speed films:

Color Negative
Fujicolor F-II 400
Kodacolor 400
Focal High Speed Color Print Film
 (ASA 400)*

Color Reversal (Transparency)
Focal 640-T Color Slide Film
 (ASA 640, Tungsten)*
Focal Color Slide Film (ASA 400)*
Fujichrome 400
Ektachrome 400
Ektachrome 200
Ektachrome 160

B&W
Agfapan 400
Ilford HP5 (ASA 400)
Tri-X Pan (ASA 400)

*These "private-label" films are made by 3M Co. The Focal brand is available at K-Mart stores.

▶ These three men are working together to pull in an anchor. Note how the chain and yellow jackets unify the group. Photographer Clay Perry used a 28mm lens.

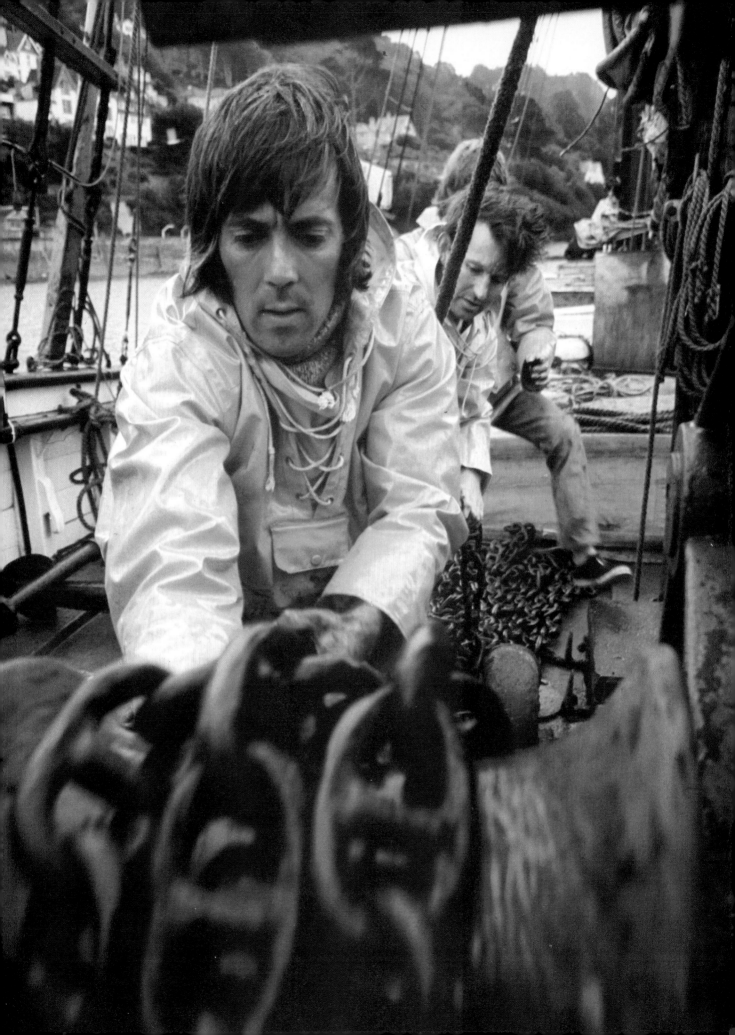

Parties and Celebrations

If you like to photograph spontaneous scenes, always have your camera handy, ready for the moment when a hot-air balloon has to make a landing in a parking lot or an eccentric blocks the rush-hour scramble. Although this is good advice, it is sometimes difficult to follow. You may prefer to go shopping without adding a camera and telephoto lens to your burden.

▶ Panning at 1/15 second blurred the kitchen. Bounce flash froze the woman and illuminated the area at the right. Both flash and window light were underexposed one step. A 35mm lens provided this wide view and good depth of field. Photo by Richard and Sally Greenhill.

▲ John Garrett hung black velvet behind the Christmas tree to separate it from the clutter around it and bracketed exposures.

▲ Next, he experimented with a cross-star filter, again bracketing exposures.

And few commuters want to think about photography on the way to work. Even when you are at home or on vacation, and you and your camera are inseparable, you *still* might miss the high points of an event.

Look at last year's Christmas photographs, for example. On Christmas morning, were you and your camera ready to catch the expressions on your children's faces when they opened their presents? Do you have a shot of carolers singing at your door? Did you catch the moment of joy when the new bicycle was unveiled—or did you have to accept a more self-conscious "thank you" a moment later? Even if you did manage to release the shutter at the right moment, are you entirely happy with the focus and exposure?

KEEP YOUR CAMERA READY

For candids, you can save precious time by setting the camera beforehand. Many photographs of family festivities are indoors, so load the camera with a fast film, such as ASA 400, for available-light photography. Or use a slower film and keep the flash unit mounted on the camera.

If you have an automatic flash unit, keep it preset for the most probable range of distances you will be shooting—indoors about 7 to 10 feet (2 to 3m). Then set the appropriate *f*-stop. Keep the lens focused at the right distance to save a couple of seconds. Look at the depth-of-field scale on the lens to see the range of focused distances. Keep the film advanced, ready for the next exposure. Leave the camera in an accessible place where it will be safe but easy to get to when you are in a hurry.

The best lens for photographing events at home is a moderate wide-angle, such as a 35mm for a 35mm SLR camera. The slightly wider field of view is useful when you are unable to move far away from the subject. The extra depth of field relative to a standard lens at the same *f*-stop makes quick focusing easier, too.

TIME TO EXPERIMENT

With a little thought, you can probably produce better photos this year.

When you can control the lighting, such as when using flash indoors, experiment.

▶ Usually this type of photograph is not spontaneous—it has to be planned and posed. Here, Charles Harbutt used daylight film with flash. The film is compatible with the color temperature of the flash, but not with the candlelight. The lower color temperature of the candlelight enhances the warm color of the pumpkin.

If you use the flash off the camera with a long flash sync cord, you can eliminate front-lighting effects that cause mask-like faces and uninteresting shadows directly behind the subject.

Vary the Angle—Even with the flash attached to the camera, you can still vary the lighting effect by bouncing the light from a wall, ceiling or other reflector, such as a large piece of white paper or a white sheet. This gives light that is more flattering for portraits because shadows are more open and have a softer edge.

Fill Flash—You may prefer to photograph by available light whenever possible, but don't forget the opportunities that flash gives you for subtle improvements of the scene. When shadows are dark and lack detail, use flash to open up those areas. *Fill flash* doesn't necessarily detract from the documentary effect of available light. Meter for the bright areas of the scene and then use a flash exposure two steps less than normal for the flash if used alone. Be sure to use the camera's flash-sync shutter speed—1/60 second with many SLRs. This gives detail in shadows and the effect of natural light.

Filtration—You can alter the color of the light with filters over the flash window or by bouncing the light off a cream or pale pink reflector for a warmer color. Experiment with the direction and strength of the light. Because a colored surface will not reflect as much light as a white one, you must set the flash unit to overexpose the subject slightly—about a half step. This correction is *in addition* to compensation for scattering by the bounce surface—about two steps. Try different exposures because it is difficult to predict how much light will reflect from any particular surface. If you have an automatic electronic flash, calculations are not necessary because the flash reads reflected light from the subject and turns itself off when the subject receives enough exposure.

SPECIAL LIGHTING

Photographing a festive table setting by candlelight, or a Christmas tree with lights reflected in tinsel decorations, is a challenge. On daylight film, candlelight and tungsten light reproduce orange. Sometimes this is satisfactory and adds to the warm atmosphere of the scene. But it can look strange when mixed with bluer, or colder, lighting such as daylight or flash.

For low-light photography, you should use a tripod unless you want to minimize depth of field and use a large lens aperture. Don't be afraid to work with the lens at its full aperture—just be sure to focus carefully.

A typical exposure for lights on a Christmas tree, showing the lights but little detail of the tree, is about 1/8 second at ƒ-5.6, with ASA 400 film. A face illuminated only by candlelight about 1-1/2 feet (0.5m) away requires an exposure of about 1/30 second at ƒ-4. Use these recommendations as guides only. To guarantee a

▶ Fast films, such as ASA 400, are useful in low light. Expose for the face. The background exposure, which adds atmosphere in this case, is usually less important than the person. Photo by Adam Woolfit.

▲ The warmth of light from the tree decorations and sparkler contrasts strongly with the cold blue skylight illuminating the snow. Photo by Monique Jacot.

▶ The warm candle glow adds to the intimate feeling of the occasion. Photo by John Goddard.

good exposure, make several different exposures to allow for ambient light and other variables.

Using direct flash for candlelit scenes tends to overpower the candlelight. Instead, try to reduce the power of the flash to act as a fill light. Bounce the light from a wall or ceiling for a soft, even effect. This way, you can strike a balance between the candles and the fill flash.

The highlight of a celebration dinner is often the moment when all the lights are switched off and a flaming desert is brought to the table. Burning alcohol has a weak blue flame that looks blue on daylight color film. With room lights off, make a long exposure to record the flame. You could also arrange a few burning candles to light the table for more even lighting of the overall scene.

GROUPING YOUR SUBJECTS

A dinner table decorated for a special occasion is an excellent place to photograph family and friends. It helps you keep the subjects together so you can use several camera angles and lighting effects. And, because the subjects are occupied with the meal, they won't become bored or self-conscious.

With a wide-angle lens, you can include the complete table at a relatively close distance. By standing on a chair, you may be able to raise your viewpoint so everyone is completely visible. If you want to include yourself in the photograph, use a tripod and a self-timer, if your camera allows this.

You may want to spend some time just seeing the family in terms of interesting groups, without even looking through the viewfinder.

Take photographs while people are relaxing. When children are concentrating on their toys, they are less likely to notice you framing them in the camera's viewfinder. Record the moment when two people are near each other to suggest a relationship between them, instead of merely showing two separate individuals.

One way to get spontaneous photographs of festivities is to open the curtains and take your camera outside for some shots through the window. If there is snow on the window ledge, the warm effect of the artificial light indoors will make a chilly contrast with the cold outside—and perhaps provide the ideal picture for next year's Christmas card.

Wedding Photographs

An invitation to a wedding is a perfect opportunity to practice people photography. Potential photos include candids of anxious faces before the event; the ceremonial view of the procession; formal portraits of bride and groom, family and guests, all looking their best; and group pictures. Use your prints as a wedding present for the bride and groom to supplement their album.

For many couples, their wedding is the occasion of a lifetime, so you should never attempt to take the *official* photographic record—unless you have actual experience and are sure of yourself. If you are not completely confident of your abilities, they should hire an experienced photographer for such an unrepeatable occasion.

Relieved of the full responsibility, you can learn and gain valuable experience without worrying about mistakes. *Never* get in the way of the hired photographer. You may ruin both his and your photographs.

Although you should keep your camera handy at all times, ready for the unexpected opportunity, here are some moments you can plan in advance.

BRIDE AT HOME

Before the bride leaves her home, ask her for a few minutes so you can make informal and full-length portraits inside or outside. The backgrounds will be more meaningful to her than those at the church or hall. You might also include her bridesmaids and pose her with her father, mother and other relatives. Only attempt this if you can handle your equipment efficiently. There will be no time for endless meter readings and fumbling with equipment.

AT THE CEREMONY

As a guest, you will probably go into the church or synagogue before the bride arrives. Find a place on the center aisle, near the back. You should ask permission to photograph during the ceremony. Be sure to use fast color negative film so you will be prepared for most conditions.

If the ceremony is in an office, you will probably be unable to use your camera unless the official photographer poses some shots and allows you to photograph his setups.

AFTER THE CEREMONY

The hired photographer will usually set up group shots at or near the church entrance. To get some good photographs yourself, leave the building while the couple is signing the register and find a spot to one side of the official photographer. From there, photograph the groups he arranges. While he is setting up the groups, you can photograph guests coming out of the church. This will give you some informal group shots of the guests, close together and all looking in the same direction.

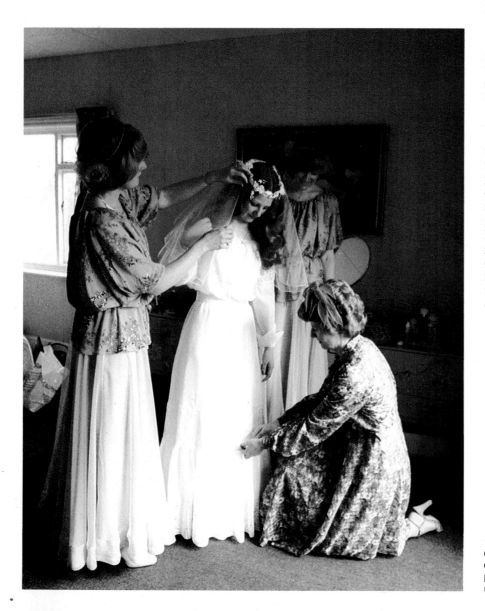

◀ When photographing scenes on a wedding day, you must stay out of the way, quietly watching for candid shots of the hectic preparations. For this picture, Derek Bayes used window light.

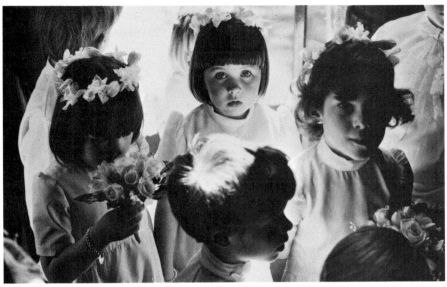

◄ The unusual placement of the light source creates some interesting effects. Tom Hustler caught a child's awed expression as she glanced at the camera.

▼ Tungsten light gives daylight-balanced film a warm, orange cast. Usually, this effect is more acceptable than the cold blue of window light on tungsten-balanced film. For this photo, Derek Bayes shot from the organist's loft with a 105mm lens.

▼ Keep an eye on what the official photographer is doing. Take advantage of the formal groups he arranges and include him in your documentary shots. Adam Woolfitt watched over the photographer's shoulder as he set up the shot, choosing the moment before the flash for his own exposure.

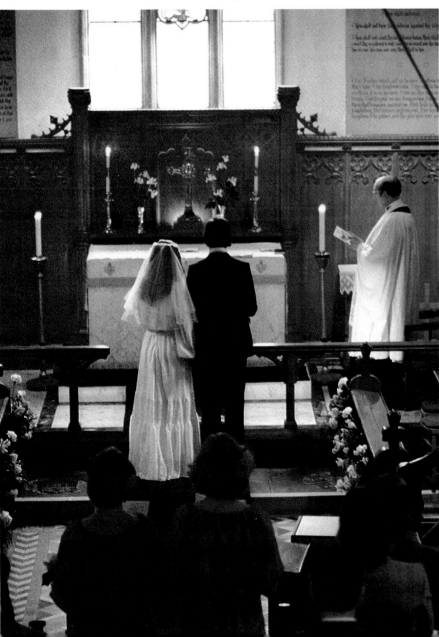

AT THE RECEPTION

Get to the reception quickly to avoid the crowd. Watch for good candids of the couple welcoming their guests. This time can also be used to take the bridesmaids and ushers aside and find a plain background indoors or a nice location outdoors to shoot some informal full-length and close-up views. Photograph brothers and sisters together, even if one is not part of the bridal party.

Next, organize candid photographs of the children eating, playing hide-and-seek or just holding hands. Use available light whenever possible, and flash fill only if absolutely necessary.

There is usually a pause after the couple has received their guests and before the main reception. This is the time to ask the bride to pose for a few special photographs with and without her husband.

Before doing this, you should have already chosen locations, camera settings and equipment, and poses. Thus, you can lead them straight to the spot and start exposing film without wasting time. Try for some romantic shots—kissing, touching champagne glasses, looking at the bouquet or at each other, and profiles in semi-silhouette. You will get maximum cooperation if you are quick and efficient.

CAKE CUTTING AND SPEECHES

When covering the reception, hired photographers often set up a mock cake cutting. If this happens, you may be able to do what you want when the cake is actually cut. You might ask the best man to pose with the bride and groom for a photograph of them holding the knife and looking at you before they actually cut the cake; otherwise, their faces may be hidden.

Toastmasters and speech makers are worth a few exposures. Watch the reactions of the couple to the traditionally off-

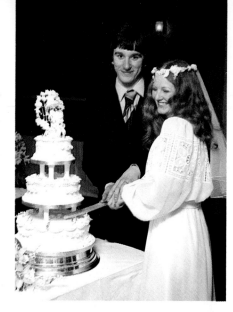

▶ On-camera flash results in flat lighting with little subject modeling. To avoid this problem, hold the flash away from the camera or bounce it from a reflecting surface. Here, electronic flash was bounced from an umbrella reflector.

▼ Look for original ideas to liven up conventional wedding photographs. Michael Boys blocked reflections with his own shadow for a clear view of his subject.

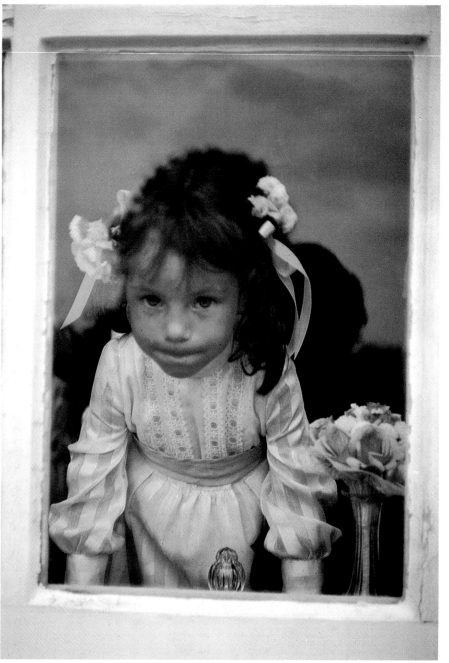

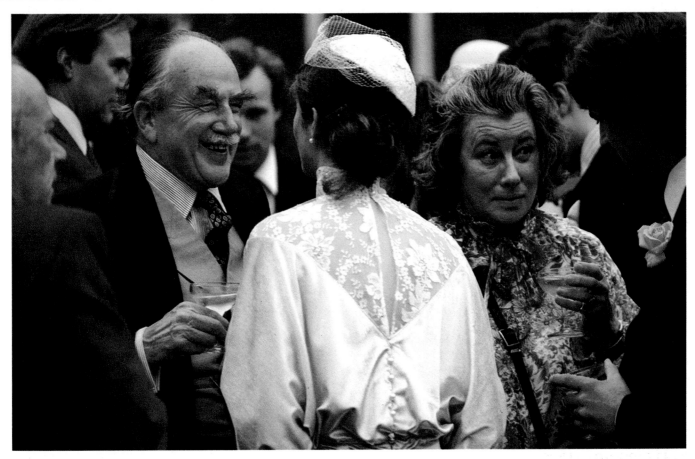

▲ Reception photographs become more candid as guests relax. John Sims used a long lens to fill the frame with faces.

▼ As hilarity takes over, be ready for the unexpected. Archie Miles caught the groom in mid-air.

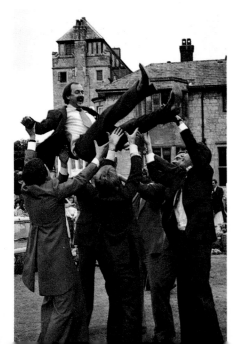

color remarks. During the toasts, position yourself behind and to one side of the couple. Photograph as many of the guests as you can. You might find a wide-angle lens useful for this. If you cannot get enough in from eye level, try holding the camera above your head, pointing it down slightly. This will include more faces at the back.

AFTER THE RECEPTION

This is a great time for candid pictures—the run down the line of guests, confetti, rice, kisses, the decorated car, the kiss in the back seat, throwing the bouquet, tears and everybody waving goodbye. The official photographer rarely waits for it, so be sure you are there.

CAMERA AND EQUIPMENT

It is essential to have a camera you are familiar with and can use quickly and efficiently. Never buy a camera for use at a special event without first experimenting with a few rolls of film and seeing the results. Don't borrow someone else's camera for this type of occasion, either.

Medium-speed film, such as ASA 64 to 100, is best for color photographs indoors with flash, or outdoors in sunlight. ASA 400 film is useful for low-light photography indoors or outside on a dark or rainy day, but use it only when necessary. When fast film is enlarged, print quality is not as good as that of slower film.

Always buy the best flash unit you can afford. Automatic exposure units are best. They should be mounted on a bracket on one side of the camera, rather than in the hot shoe. This gives slightly better modeling to faces. Many flash units can be attached to the camera with an accessory 3-foot (1m) extension so you can hold the flash higher than normal. This positions the shadow below the subject instead of directly behind.

You need experience to cover a wedding thoroughly. You will expose a lot of film but, for an important event, that is money well spent. You will probably want to give a set of the best prints to the couple as a present, but don't be afraid to charge others a fair price to offset your expenses and pay for your time.

THE OFFICIAL RECORD

If you have to think twice about taking responsibility for the official wedding photographs, don't do it. If you *are* doing it, however, remember that the pictures the bride wants have priority over those you may want. Here is a guide to the photographs the bride will expect you to include.

Arrivals—Catch the groom arriving with the best man. Take another shot or two of the groom on his own.

Then photograph the bride arriving with her father.

Bride Alone—Some photographs of the bride posed quietly alone are important. They should be close-up, three-quarter and full length. The veil should not be over her face. Her body should be turned away from the camera slightly and her head toward it, with the bouquet also turned slightly. Her arms should be slightly bent at the elbows. If there is a long gown or veil, it should be brought around from the back, but not so far that it looks unnatural.

These photos can be taken with soft-focus lens accessories. This is especially useful if the lighting is contrasty. The soft-focus accessory will distribute light into shadow areas to reduce contrast in the image.

These pictures are best taken before the ceremony, at home or at the church. If necessary, however, you can make them during a quiet period at the reception.

Signing the License—Although church offices are usually small, a quick, posed shot of people signing the marriage license is usually requested by the family. Be sure to use a wide-angle lens when you're in a small room.

At the Altar—If photography is allowed during the vows, be inconspicuous and discreet. If photography is not allowed, you may be able to pose a special shot afterward.

Groups—These are best taken at the church—either near the altar or outside the door. This is one occasion when you'll find a tripod essential. Use it while framing the scene and to help you keep composition constant for different groups. Go to the church early so you can work out the best position beforehand. This helps you work faster—a necessary skill in group photography.

First try several full-length and three-quarter-length photographs of the bride and groom looking at the camera.

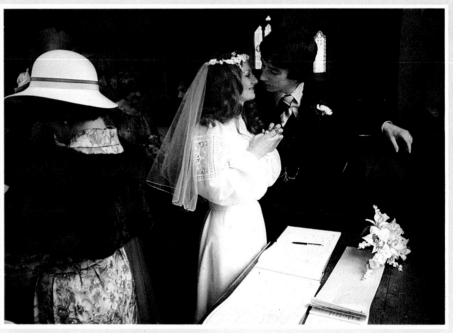

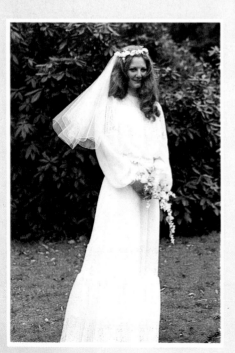

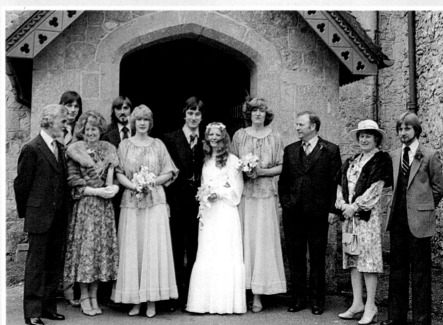

As the bridesmaids and families appear, take control of the situation right away. Ask the best man to stand with the couple, next to the bride. Then add the bridesmaids and ushers, placing them to each side. A child can stand in front of the bride, but be careful not to hide the bride's gown.

Next, have the two sets of parents standing next to the couple. The bride's parents should be on her side and the groom's on his. Reposition the bridesmaids on the outside of the group with the children spread out in front to block the adults' legs, leav-

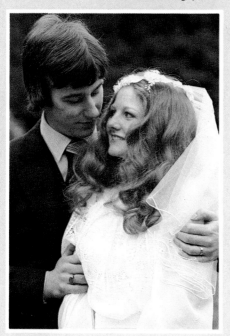

ing the bride and groom clear in the middle.

Then you can add close relatives. If there are too many, it will create an unwieldy group. You may want to use a wide-angle lens at this point, or organize separate groups for tighter compositions.

Leaving the Ceremony—Position yourself for some shots of the couple walking to the car and getting into it together. Try for a close-up shot of the couple inside the car. Flash may be useful here. Finally, get some good photographs of the guests waving as the couple leaves.

For more hints about wedding photography, read Tom Burk's *How to Photograph Weddings, Groups & Ceremonies* also published by HPBooks.

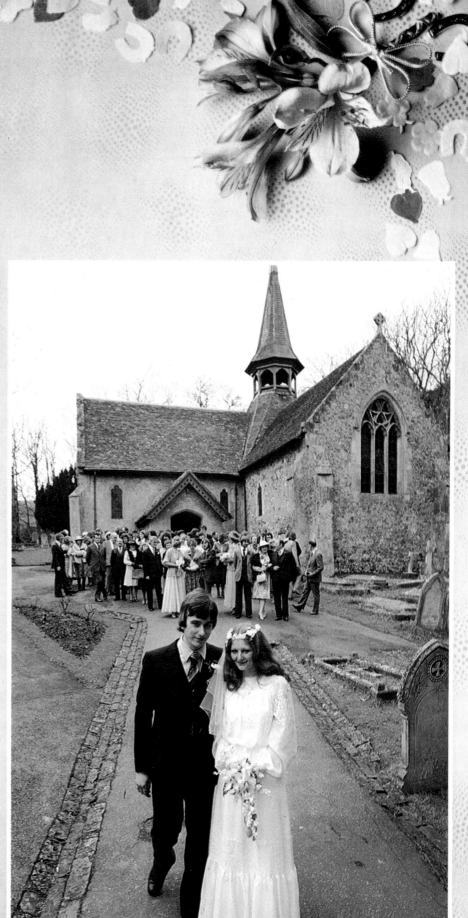

Glossary

A

Afocal Lens: A lens accessory that attaches to a camera lens to decrease the focal length.

Angle of View: The angle between the two rays that determine the diagonal of the film frame. Angle of view increases as focal length decreases.

Aperture: The adjustable opening in a lens that controls the brightness of the image exposing the film.

Aperture Priority: See *Automatic Exposure.*

ASA: An abbreviation for the *American Standards Association*, the organization that devised a film-speed rating for general-purpose films. As the ASA number doubles, film speed increases by one exposure step. Also see *DIN* and *ISO.*

Automatic Exposure: Camera metering system that sets shutter speed, lens aperture, or both after metering. There are three types: *Aperture priority* means you set aperture, camera sets shutter speed; *shutter priority* means you set shutter speed, camera sets lens aperture; *programmed* meters set both shutter speed and aperture.

Autowinder: Motorized unit that automatically advances film and cocks the camera shutter after exposure. This is an accessory with some cameras; built into others.

B

B (bulb) Setting: The shutter remains open as long as the shutter button remains depressed.

Barn Doors: A lighting accessory used to restrict the light beam. Usually composed of three or four swinging doors.

Bayonet Mount: A quick-locking and quick-release fitting between the camera and lens or lens accessory.

Bracketing: Making a series of frames having different exposures. By making the metered exposure and frames with more and less exposure, you have a good chance of getting one picture that has "perfect" exposure. Bracketing is typically done in half- or full-step increments.

C

CC Filters: Also called *color-compensating* filters, these are filters available in a variety of colors and densities. They are usually used for fine color control of color film exposure.

Catadioptric Lens: See *Mirror Lens.*

Color Negative: Film that yields reverse tonalities and colors after exposure and processing. Used to make color prints. Negative has an orange cast that does not appear in the print.

Color Reversal: Color film or paper that yields correct tonalities after exposure and processing. Also called *color positive*. Color reversal films and papers usually have the suffix *-chrome* in their name.

Color Temperature: A scale of values that represent the relative amounts of red, blue, and green light in a light source. Values are represented in degrees Kelvin (K), in which the higher the number, the bluer the light source. For example, midday daylight has a color temperature about 5500K. Candlelight, which looks much redder, has a color temperature about 1800K.

Complementary Colors: Yellow, magenta and cyan.

Composition: The arrangement of parts to form a unified whole.

Conversion Filter: Any colored filter designed to change the color temperature of the light to match the sensitivity of the film. Also called a *light-balancing* filter.

Cool Colors: Violets, blues and greens.

Cropping: Selecting the framing of the image. You do this when viewing a scene through the camera viewfinder. Some photographers also crop the image later during printing.

Cyan: A color formed by combining blue and green.

D

Daylight-Balanced Film: Color film designed to give best color reproduction when exposed with 5500K light. See *Color Temperature.* Daylight-balanced film is available as color negative and reversal film.

Depth of Field: The distance between the nearest and farthest points of acceptable focus. Increase depth of field by decreasing image magnification, using small lens apertures, or both. Decrease depth of field by doing the opposite.

Depth-of-Field Preview: A control on the lens or camera that you use to manually stop down the lens aperture, allowing you to see depth of field through the viewfinder.

Differential Focusing: The technique of using large lens apertures, long-focal-length lenses, or both to create a narrow depth of field. This separates the focused subject from the out-of-focus foreground and background. Also called *Selective Focusing.*

Diffuser: Any material that scatters a beam of light.

DIN: An abbreviation for *Deutsche Industrie Normen*, a German organization that devised the European film-speed rating for general-purpose films. As the DIN number increases by 3, film speed increases by one exposure step. DIN and ASA speed ratings agree at a film speed of 12. Also see *ASA* and *ISO.*

E

Electronic Flash: Light created by ionization of xenon gas due to rapid discharge of electrical energy. Color temperature of typical flashes is about 5500K. See *Color Temperature.*

Enlargement: Photographic print made from a negative or transparency that is larger than the original image.

Exposure: The amount of light that strikes a film—the product of illuminance and time. Exposure is determined by shutter speed and lens aperture.

Exposure Meter: See *Meter.*

F

False Attachment: Compositional mistake that makes a background element appear to be connected to a foreground subject.

Fast Film: General classification of films with ASA speeds of 400 or higher. See *ASA.*

Film Speed: A numbering system that compares the relative sensitivity of films to light. As sensitivity increases, so does film speed. See *ASA, DIN, ISO.*

Filter: Any material that absorbs light. Filters can be made of glass, plastic or gelatin. They can be used over the camera lens or light source.

Fisheye Lens: An extreme wide-angle, small focal-length lens with an angle of view greater than 100°. A fisheye produces distorted images by curving lines that do not pass through the center of the image.

Flare: Unfocused, non-image forming light that exposes film. Typically, flare is from a bright light source shining toward the lens. It tends to expose shadow parts of the image, lowering image contrast.

Flash Sync Speed: Fastest camera shutter speed that works with electronic flash. With electronic flash and focal-plane shutter this is 1/125, 1/90, or most commonly, 1/60 second. With leaf shutters, electronic flash sync occurs at all shutter speeds.

Floods: See *Photofloods.*

Focal Length: Distance between the film plane and the *optical* center of a lens measured when the lens focuses rays from infinity to a point on the film plane.

Focusing Screen: Piece of plastic or glass that intercepts the image formed by the lens and reflected up by the mirror of an SLR camera. It is what you see when you look through the camera viewfinder.

f-stops: Series of numbers marked on lens aperture ring that represent the size of the lens aperture. Common f-stops are f-1.4, f-2, f-2.8, f-4, f-5.6, f-8, f-11 and f-16. Larger numbers represent smaller openings, and vice-versa. The exposure difference between f-stops in this series is one step.

H

Highlights: Brightest areas of a subject or image. The opposite of shadow.

Hot Shoe: Flash holder on a camera that automatically connects to flash's circuitry when flash is attached. External sync cord is not necessary.

Hue: The basic color an object has.

Hyperfocal Distance: The near limit of depth of field when the lens distance scale is set to infinity. If the lens distance scale is set to the hyperfocal distance, the far limit of depth of field is infinity, and the near limit is half of the hyperfocal distance.

I

Interchangeable Lens: A lens that detaches from the camera, allowing another interchangeable lens to be attached. See *Bayonet Mount.*

Infrared: Invisible part of the electromagnetic spectrum that has wavelength longer than that of red light. We sense it as heat.

Incident-Light Reading: A meter reading made by measuring light illuminating the scene. This is a method done with a hand-held accessory meter called an *incident-light meter.*

ISO: Abbreviation for *International Standards Organization,* which uses ASA and DIN speed ratings to indicate film speed. For example, an ASA 100 (DIN 21) film is also rated ISO 100/21°. See *ASA* and *DIN.*

L

LED: Abbreviation for *light emitting diode,* which is a small electronic device that glows. LEDs are used for exposure displays that are visible in camera viewfinders.

Lens Hood: A conical or rectangular tube of metal, plastic or rubber that attaches to the front of a lens. It blocks stray light from striking the front element of the lens. This preserves good image contrast.

Light: Visible part of the electromagnetic spectrum. It is the colors we see and photograph.

Long-Focus-Lens: A lens with a long focal length, typically greater than 150mm in 35mm photography. Also see *Telephoto Lens.*

M

Magenta: A color formed by combining blue and red.

Meter: Device that measures light. It recommends camera settings for good exposure.

Mirror Lens: A lens that uses mirrors in addition to conventional lens elements to focus light rays.

N

Neutral-Density (ND) Filters: Gray-colored filters that absorb light without changing its color balance. Used to reduce the light striking the film.

Newton's Rings: Multicolored lines created when two transparent surfaces make non-uniform contact with each other. Sometimes occurs with glass-mounted slides.

P

Pentaprism: An optical device used in a camera viewfinder to make a laterally-reversed image read correctly from left to right.

Perspective: The relative sizes, shapes and distances of three-dimensional objects reproduced in two dimensions. In photography, you control perspective by camera location.

Photoflood: A photographic lamp using a tungsten filament. Yields 3200K or 3400K light.

Polarized Light: Light that vibrates in only one plane along its line of travel.

Polarizing Filter: A filter that absorbs polarized light. Used to accentuate colors or reduce reflections from materials other than unpainted metal.

Primary Colors: Blue, green and red.

Push-Processing: Extended development time of a film to compensate for underexposure. This essentially yields a "faster" film because you can expose the film at a higher-than-normal film speed. This technique is used with color and b&w film. Typically, film contrast increases and color balance may shift.

R

Reciprocity Law: This law states that exposure is the product if illuminance (aperture) and time (shutter speed). For a certain exposure, a variety of shutter-speed and lens aperture combinations can be used of their "products" yield the same exposure.

Reciprocity Law Failure: This occurs when shutter speeds are very long or very short. Film appears underexposed even though the calculated exposure should give good results. When using general-purpose films, this occurs with speeds longer than 1/2 second or shorter than 1/10,000 second.

Red Eye: The phenomena of flash light reflecting from blood vessels in subject's eyes so the retinas reproduce bright red on color film. Happens only when flash is very close to lens-to-subject axis. Avoid the problem by having the subject look away slightly, or move the flash away from the lens-to-subject axis.

Reflected Light Reading: A meter reading made by measuring light reflected from elements in the scene. This is the method used by most built-in camera meters.

Reflector: Any material that bounces light. Smooth silver or white materials reflect the most light without changing its color balance.

Retrofocus Lenses: Lenses designed with the optical center behind the rear lens element. This design makes interchangeable wide-angle lenses possible.

Reversal Film: Color film that yields correct tonalities after exposure and processing. Also called *color positive* or *slide film.* Color reversal films usually have the suffix *-chrome* in their name.

S

Saturation: The purity of a color. Purest colors are spectral colors with 100% saturation.

Selective Focus: Using reduced depth of field to place the subject of interest in sharp focus with the rest of the scene out of focus.

Shutter: The camera mechanism that controls the duration of exposure.

Shutter Priority: See *Automatic Exposure.*

Single-Lens Reflex (SLR): Classification of cameras that use one lens for viewing and taking the picture. During viewing, a mirror reflects the image to the viewfinder. During exposure, the mirror moves out of the way of the image, which strikes film behind the open shutter.

Skylight Filter: A filter that absorbs ultraviolet (UV) radiation and some blue light, reducing the excessive blueness in color images. No exposure compensation is necessary.

Slave Cell: Device that senses flash light and almost instantly creates an electrical impulse to trigger another flash connected to it.

Slide: Image on film that has correct colors or tonalities. Used in projector for viewing an enlarged image. See *Color Reversal.*

Slow Film: General classification of films with ASA speeds of 64 or lower. See *ASA.*

Snoot: Lighting accessory that limits a beam of light to a small area.

Spectrum: The range of electromagnetic radiation organized by wavelength. The visible part of the spectrum (see *Light*) includes short blue wavelengths and long red wavelengths. Ultaviolet radiation is invisible and has wavelengths shorter than blue light. Infrared radiation is invisible and has wavelengths longer than red light.

Standard Lens: Lens with angle of view between 40° and 59°. With the 35mm format, this is a lens with a focal length between 45mm and 55mm. Many cameras are sold with a lens in this range.

Stopping Down: Selecting a smaller lens aperture (bigger *f*-number). Increases depth of field, cuts down light illuminating film.

T

Teleconverter: Lens accessory that fits between the camera and lens to increase lens focal length, thereby increasing image magnification. A *2X teleconverter* doubles lens focal length. A *3X* triples it.

Telephoto Lens: A lens designed with its optical center toward the front of the lens. This allows interchanging various long-focal-length lenses on a camera body. This expression is also used to describe any lens with a focal length longer than standard. With 35mm photography, this includes lens focal lengths longer than 55mm.

Tone: The shade of a color. Most often used in b&w photography, when a neutral color, such as white, gray or black is described.

Transparency: An image with correct tonalities or colors on film. Used in a slide projector for enlarged viewing. Also called a *slide.* See *Color Reversal.*

TTL: Abbreviation for *through-the-lens* used when referring to a camera with a built-in meter that reads the light through the lens.

Tungsten-Balanced Film: Color film designed to give best color reproduction with 3200K or 3400K light. Also called *Tungsten Film.*

Tungsten-Halogen Lamp: Light source using a tungsten filament in a halogen gas. This type of bulb has a long life.

U

Ultraviolet Radiation (UV): Invisible radiation that can expose film. Reproduces as blue with color film, as low-contrast haze in b&w. Most prevalent at high elevations or when you photograph distant scenes. Effect removed by using a UV filter. See *Spectrum.*

V

Variable Focal Length Lens: Lens with more than one focal length. Change focal length by adjusting a ring that moves lens elements. Also called a *zoom lens*.

Viewfinder: Part of the camera you look through to see the image on the focusing screen. On most 35mm cameras, the viewfinder is a pentaprism that shows the focusing-screen image right side up and laterally correct.

Viewpoint: Location of camera relative to subject. Changing viewpoint changes *perspective*.

Vignetting: Image cutoff due to light rays being intercepted before they can expose film. Typically occurs in the corners of the image.

W

Warm Colors: Yellow, reds and oranges.

Wide-Angle Lens: Classification of lenses with angles of view smaller than that of the standard lens. With the 35mm format, this term used for any lens with a focal length smaller than 40mm.

Z

Zoom Lens: Lens with more than one focal length. Change focal length by adjusting a ring that moves lens elements. Also called a *variable focal length lens*.

Index

Front Cover Photos:
Royal Guards by Homer Sykes,
baby by John Garrett,
woman and mule by Michael Busselle.

Back Cover Photo:
Clay Perry

A-5.574752707